Healing Arts Therapies and Person-Centered Dementia Care

Bradford Dementia Group Good Practice Guides

Now under the editorship of Murna Downs, this series constitutes a set of accessible, jargon-free good practice guides for the carers of people with dementia. Reflecting the group's commitment to the person-centred approach to dementia, the series draws on both experience in practice and the latest research in the fields of dementia and dementia care.

Training and Development for Dementia Care Workers
Anthea Innes
ISBN 1 85302 761 8

Primary Care and Dementia
Steve Iliffe and Vari Drennan
ISBN 1 85302 997 1

Drug Treatments and Dementia
Stephen Hopker
ISBN 1 85302 760 X

Social Work and Dementia
Good Practice and Care Management
Margaret Anne Tibbs
ISBN 1 85302 904 1

The Pool Activity Level (PAL) Instrument for Occupational Profiling
A Practical Resource for Carers of People with Cognitive Impairment, Second Edition.
Jackie Pool
ISBN 1 84310 080 0

Bradford Dementia Group Good Practice Guides

Healing Arts Therapies and Person-Centered Dementia Care

Edited by
Anthea Innes and Karen Hatfield

Jessica Kingsley Publishers
London and New York

First published in the United Kingdom in 2001 by
Jessica Kingsley Publishers Ltd
116 Pentonville Road, London
N1 9JB, England
and
29 West 35th Street, 10th fl.
New York, NY 10001-2299, USA

www.jkp.com

Printed digitally since 2004

© Copyright 2001 Jessica Kingsley Publishers Ltd

Library of Congress Cataloging in Publication Data
A CIP catalog record for this book is available from the Library of Congress

British Library Cataloguing in Publication Data
A CIP catalogue record for this book is available from the British Library

ISBN 1 84310 038 X

Contents

Preface

Anthea Innes

The concept of person-centered care is now common currency in the dementia care field both within the UK and the USA. Implementing person-centered care is however an issue that has vexed practitioners (Poole 2000; Packer 2000), although there are accounts of individuals who have attempted to implement the theory and philosophy of person-centered care (Innes 2000; Mills 2000; Petrie 2000; Tibbs 2000). The challenge that remains for dementia care practitioners is to continue using and developing initiative, sensitivity and creativity in their work with people with dementia. During a visit in October 1999 to what at that time was named Heather Hill Hospital, Health and Care Center, in Ohio, USA, I was initiated to the concept of 'healing arts therapies' in dementia care. I experienced first-hand a drumming session, saw the art work and heard all therapists speak with enthusiasm and conviction of the great and small healing powers of music, dance and art in their work with people with dementia.

This guide brings together the experiences of these skilled and committed therapists who work with people with dementia in the areas of dance, music and art on a day-to-day

basis under the direction of Roseann Kasayka, herself a music therapist. Each contributor shares with us the theory underlying their modality, practical examples of their application of dance, music or art in their work with people with dementia as well as practical 'tips' that the non-therapist could draw upon to enhance the care they offer. The conclusions that are drawn are formed from practice and application of the therapy and principles of person-centered dementia care. Holly Queen-Daugherty's chapter provides visual examples of the work of persons with dementia alongside a narrative describing the process of art therapy as experienced by the individuals whose work is presented. Liat Shustik and Tria Thompson provide us with examples of using movement and dance to express emotions, to offer comfort and simply to 'be' together. Karen Hatfield and Natalie McClune talk us through the simple pleasures that music can bring for both the therapist and the person with dementia while detailing initiatives tried and tested at Heather Hill that have brought a sense of relaxation, team work and valuing of individuals with dementia. Parallels between person-centered dementia care and healing arts therapies are drawn throughout the book, illustrating that Kitwood's concept of positive person work (1997) has a powerful outlet in music, dance and art work with people with dementia. This guide provides us with a blueprint of what can be achieved by qualified therapists while at the same time offering windows of insight into what can be achieved by the non-therapist who wishes to experiment with the activities of art, dance and music.

Introduction

Roseann E. Kasayka

The core functions of healing arts therapies in the care of persons with dementia are the reclamation, the regeneration and the celebration of the human spirit. These are also the primary goals of person-centered care. Each of these therapies flows from a similar deep concern for the support of personhood and the well-being of the individual. Each has a concern for fullness of life, and puts connection, interaction and communication, both verbal and nonverbal, at the top of the list of priorities in terms of care goals. The healing arts therapies and person-centered care are natural partners.

Throughout this book the definition of healing arts therapies used is: 'holistic therapeutic modalities that promote wellness and growth'. In the case of music, dance/movement and art therapies, the form of the therapy is taken from the fine arts. These three modalities involve the intentional and compassionate use of the elements of their particular art form to promote physical, emotional and spiritual well-being. Person-centered care is care which focuses on the person rather than on dementia, the disease. Person-centered care operates from the residual strengths of the individual, considering what

they can do rather than what they are unable to do. Person-centered care holds that no matter the level of cognitive impairment, the individual with dementia can have a good quality of life and be in a state of well-being.

In the USA, the interest in and growth and use of the healing arts therapies has burgeoned in the recent past. In the expanding body of research literature that supports the use of these therapies, there has been an accumulation of evidence testifying to the fact that the arts provide an unsurpassed means of communication, joy and accomplishment to persons who are ill, have neurological damage or are cognitively impaired. The effectiveness of arts therapies with these persons, and their success more generally in promoting and preserving wellness is well researched and documented.

Sandel (1992) considers the modalities of music, dance/movement and art therapy together. She notes general outcomes in the care of patients when these modalities are used in treatment. In summary, these outcomes include but are not limited to:

> *Increasing orientation and activation*: The creative arts therapies provide a structured interpersonal environment in which organized sensory stimulation, interpersonal interaction and physical action facilitate orientation, attention and arousal.

> *Facilitating reminiscence and remembering*: By providing concrete physical and imaginative cues through sound, touch, movement and visual forms, the creative arts therapies enhance the processes of reminiscence and remembering by facilitating access to deeper memories, as well as the subsequent sharing of these memories with others in a group context.

Increasing self-understanding and acceptance: By
encouraging spontaneous expression through the arts
media, aspects of the self that have been kept from
awareness often emerge. Work in these media usually
increases people's curiosity about their feelings and
inner lives. With the help of a therapist or other
members of the group, people can discover the
unique meanings of their self-expressions and learn
about their strengths and come to accept any
limitations that they may have.

Developing meaningful interpersonal relationships: The
creative arts therapist provides a means of structured
communication among people. Intimacy is created
through the mutual expression of aspects of their
inner lives. Because of the nonverbal nature of the
arts media, people with cognitive or language
deficits can participate equally. The atmosphere of
play, fun and spontaneity contributes to the bonding
among members of the group.

Building communal spirit: Communal artistic events
such as murals, songs, performances, celebrations or
workshops have the power to link people of
divergent backgrounds, cultures, ages or conditions
and to articulate their common bond. The arts
support a sense of belonging that expresses the inner
vision of those who participate in them.

The above parallels two of Kitwood's constructs described in
his book *Dementia Reconsidered: The Person Comes First*. The first
of these focuses on what a person with dementia needs.
Kitwood (1997) notes that we might consider these needs in a
kind of cluster, as they are very close to each other and function

in a kind of cooperative. He uses a flower model to illustrate these needs (p.82). At the center of the flower is love. It is a common need of persons with dementia, indeed of all persons, to love and be loved. The type of love that Kitwood preaches is not romantic love or a kind of love that is only there when it is convenient. Rather, the love needed is a practical love. This is love that makes the space safe and stands by the individual no matter what the situation, no matter what the confusion, no matter what the emotion. This type of love is unconditional and without expectation of return. It holds the characteristics expressed by St. Paul in his first epistle to the Corinthians, Chapter 13, verses 4–8. Here Paul speaks of love being: patient and kind; never jealous; never boastful or conceited; never taking offense; not resentful; does not rejoice in the trouble of others; always ready to forgive, to trust, to hope. This type of love endures whatever comes and is itself enduring until the end of time.

Going around the center circle of love, Kitwood then lists five other needs. They are: comfort, attachment, inclusion, occupation and identity. While each of these is in some ways an extension of the concept of love, each also holds a particular expression that makes it unique and worthy of delineation and description.

Kitwood describes *comfort* as carrying 'meanings of tenderness, closeness, the soothing of pain and sorrow, the calming of anxiety, the feeling of security which comes from being close to another' (p.81). To provide comfort for a person with dementia involves the mobilization of warmth and strength to be able to stand with the person and 'enable them to remain in one piece when they are in danger of falling apart' (pp.81–82).

Attachment is the need to be bonded to others and to know that, despite losses of primary relationships, there still is a group of persons that accepts one. This need flows into the

need for *inclusion*, the need to be accepted into a group and to be part of the social life of that group.

The need for *occupation* is met when the person with dementia is engaged in activity that is meaningful, significant and personally appropriate. This type of activity may be work-like or may take the form of participation in intellectual activity, media or the arts. Knowing the individual's past and what has been meaningful to them helps in the planning of appropriate occupation.

Kitwood says:

> To have an *identity* is to know who one is, in cognition and in feeling. It means having a sense of continuity with the past; and hence a 'narrative', a story to present to others. It also involves creating some kind of consistency across the different roles and contexts of a person's life. (Kitwood 1997, pp.83–84)

It is important to note that when a person with dementia cannot remember who they are or who they were, staff, by knowing the individual's history, can help them to remember. Thus the individual's uniqueness and contribution can be held up and honored.

The second construct put forth by Kitwood is the practice of positive person work. According to Kitwood (1997, pp.90–92) there are twelve positive interactions that comprise positive person work:

> **Recognition** – the person with dementia is acknowledged as a unique and individual person, known by name and revered for who they are.

> **Negotiation** – in this type of interaction, the person with dementia is consulted about their preferences,

desires and needs rather than having the carer make assumptions about the same.

Collaboration – involves a kind of 'working together' to accomplish a shared task; often the shared task is that of giving care whereby the person cared for offers their own abilities and initiative to the care process.

Play – involves the kind of spontaneous activity that has no other particular goal than self-expression and enjoyment.

Timalation – involves a type of interaction in which the senses are the main focus for engagement rather than interactions which involve an intellectual or emotional component (e.g. aromatherapy, massage etc.).

Celebration – involves acknowledging and holding up moments that are intrinsically joyful and participating in them to the fullest capacity.

Relaxation – involves a letting go of bodily tension and a sense of comfort in sharing that tension-free slow pace with others in the common group.

Validation – involves accepting the 'subjective truth' of the person with dementia, attempting to understand the person's frame of reference, accepting the reality of their emotions and feelings and responding on a feeling rather than a solely intellectual, reality-based level.

Holding – means providing a safe psychological space into which the person with dementia can bring

any feeling or emotion and know that all will be accepted.

Facilitation – enables a person to 'do what otherwise he or she would not be able to do, by providing those parts of the action – and only those – that are missing' (p.91).

Creation – the person with dementia takes the lead and spontaneously offers the group something from his or her own ability and/or social skill (e.g. reading a favorite poem to the group).

Giving – the person with dementia, because of their own sensitivity, expresses concern, affection, a desire to help or a sense of gratitude.

Sandel's (1992) outcomes and Kitwood's (1997) statement of the needs of the person with dementia as well as Kitwood's description of positive person work are closely connected. Though stated in different language, Sandel's outcomes reflect a way of making operational Kitwood's philosophy of needs and his description of positive person work. Participation in the healing arts therapies, both as an individual and in group session, has the special potential to work in the five last categories of positive person work, namely validation, holding, facilitation, creation and giving. In healing arts therapies the individual is validated on a feeling level, encouraged to express emotion and supported in making sense of or putting order to chaotic feeling. Being able to create a holding environment, a space that is safe and supportive, so that it can contain and catalyze whatever expression of experience or feeling that needs to happen, is the first prerequisite of the healing arts therapist. Facilitation of interaction between therapist and the individuals, and in the case of groups between members of the

group, is central to healing arts therapies. When these sessions are well facilitated, the person with dementia accesses creativity and interacts with the therapist and other persons with dementia with warmth and concern, giving and receiving. In the healing arts therapies, person-centered interventions are the rule-of-thumb. In these disciplines, it is the intention of the therapist to meet and match people where they are rather than to direct and change them and take them to some place that seems better to the therapist. Person-centered interventions in the context of healing arts therapies truly allow for and facilitate continued growth, expansion and healing regardless of cognitive function.

Transformation of life is the goal of the healing arts therapies. Transformation of care and therefore transformation of life of the person with dementia as well as those who love and care for them is the goal of person-centered care. As the fine arts influence and transform life, and as the fine art of regard of person influence and transform life and care, so the healing arts therapies and person-centered care can have the same effect.

Expression through these therapies is powerful because it assures us that significance, meaning and beauty can emerge from pain, confusion and trauma. Each of the healing arts therapies has the potential to make a connection or reconnection to beauty and therefore to the joy of a significant life. Music, dance/movement and art therapies do this through their foundation in and mirroring of the fine art forms. Person-centered care does this through its foundation in a humanistic philosophy that upholds the inherent dignity and beauty of the human person simply because they exist as a person.

Beauty is a sublime but sometimes elusive concept. Beauty of person, as supported by person-centered care, and beauty of expressive form, as supported in the healing arts therapies, are but two expressions of the universal concept that is a common

language to all people. Participation in beauty erases the boundaries between persons and overcomes distinctions. There is no we and they, there is only the us that stands together in awe as we witness and participate in beauty. Beauty inspires us to celebrate our common humanity and to delight in its expression in the world of art. The presence of beauty is a constant reminder that wholeness is possible and that life is significant. The physical and psychic remembering that wholeness is possible is the cornerstone of the healing process. Rollo May (1976) has written about beauty and reflected on its attributes. His treatise is, in some parts, almost an ode to personhood as he connects the concept of beauty to the concept of what is most human and most universal in all of humankind. He says:

> Beauty is the form which reaches most deeply into the human heart and mind. It is the language which translates all the moods of humanity into feelings, insights and sensual experience that we can understand. In beauty there are no foreigners; the deeper we penetrate into the human soul, be it of ourselves or our neighbors, the more we find ourselves at one with people of all nations... It is by beauty that we feel the pulse of all mankind. (May 1976, p.240)

The following chapters attempt to explore this universal beauty by considering the application of healing arts therapies as person-centered care for persons with dementia.

Chapter 1

From the Heart into Art
Person-Centered Art Therapy
Holly Queen-Daugherty

We gather together, just as we are – as people. Each precious and full of wisdom. We share our gifts. Treasures of the heart are offered in a picture, an image, a poem, a caring touch. People looking into each other's eyes, listening, crying, laughing, joking, being. Looking at the soul. A picture is a window, an expression of the inner self. 'Here there is no right or wrong.' 'There are no mistakes in our art and everything we create is beautiful.' This is a safe place. Nothing profound is expected, yet that is exactly what occurs. When I am transparent with you, and you are transparent, we can see how truly precious we are. Even without words, we can speak the same language in colors.

ART THERAPY
As part of the Healing Arts Department at University Hospitals Health System and Heather Hill Hospital & Health Partnership, the art therapy program seeks to use art with intention

and compassion to respond to the physical, emotional and spiritual needs of the person. Attention to quality of life and the autonomy, expressive liberation and connection that art restores to lives affected by dementia are prime considerations of the art therapist.

> Art Therapy is a human service profession that utilizes art media, images, the creative art process, and resident/client responses to the created products as reflections of an individual's development, abilities, personality, interests, concerns, and conflicts. (Foth 1999)

> Art Therapy practice is based on knowledge of human developmental and psychological theories which are implemented in the full spectrum of models of assessment and treatment including educational, psychodynamic, cognitive, transpersonal, and other therapeutic means of reconciling emotional conflicts, fostering self-awareness, developing social skills, managing behavior, solving problems, reducing anxiety, aiding reality orientation, and increasing self-esteem. (Foth 1999)

In this chapter I will attempt to integrate established theories of art therapy with the framework of person-centered care, resulting in a narrative intended to provide a means of effective art therapy for persons with dementia. It is hoped that this will be a useful resource for art therapists working in the field as well as other professionals seeking to provide support through a greater understanding of this work.

PERSON-CENTERED DEMENTIA CARE AND ART THERAPY

Tom Kitwood, a pioneer in person-centered care with individuals with dementia, drew upon his wisdom, experience, and research to diagram the psychological needs of the person with

dementia. He used the image of the flower when explaining these needs, with love at the center surrounded by comfort, attachment, inclusion, identity, and occupation. Art therapy seeks to address and provide opportunities for fulfillment of these needs.

> Existentialism implies an interest in the human struggle with deep issues of life in the face of death. Anxiety, conscience, relationships, concern, guilt and love all receive significant attention from prominent existential writers. (Moon 1995, p.ix)

In day-to-day interplay with persons with dementia it is inescapable to address existential struggles and innate issues. Scenarios include a woman feeling guilty, as though she has abandoned her children and husband, yet does not know the way to return home or the reason she is away from her family; a man in the search of 'heaven on earth' and a place of safety. These people are not facing death in the literal sense, but instead are facing the death of a sense of identity, life roles and autonomy. I believe it is helpful to utilize an existential theoretical base in the creative and therapeutic process. When a person with dementia is experiencing such existential life issues, it would be neglectful not to address matters such as anxiety, guilt, relationships and love. Whether the therapist offers a highly structured art task or promotes spontaneous expression, the image will always reflect the person's internal experience through color, metaphor, dialogue, and title. The image is indeed a 'canvas mirror' (Moon 1995).

PROCESS VERSUS PRODUCT

Existential theory and a person-centered approach go hand-in-hand in the practice of art therapy with persons with dementia. The focus is on the individual's existential needs and

values, while giving significant emphasis to the creative process despite the product. Cronin and Werblowsky (1979) define process well:

> By process is meant the entire sequence of events from the moment a patient begins a drawing until the conclusion of the session. Process includes the patient's behavior and affect; the patient's comments or associations; the evolution of the drawing itself; the patient's use of materials; the carryover from drawing to drawing. (Cronin and Werblowsky 1979, p.104)

Of course, the end product is a valuable tool for self-reflection and distancing. Distancing means to create both physical and psychological space from one's image for the purposes of gaining clarity and new perspective. Much of the therapeutic benefit takes place during the creation of the artwork in the peer interactions and dialogue between group members and with the image. It is often the belief of art therapists that the 'essential role of the therapist is to create something during the course of the group that is lasting' (Kahn 1983). The nature of creating a concrete, tangible end product is a distinction that art therapy favors in comparison to music therapy or dance/movement therapy. Kahn also states: 'A product or end result is available to the Alzheimer's resident to develop memory retention of the experience'.

One can pose the questions, 'Does the "something" that lasts need to be a completed and matted piece of artwork?' and 'Can the "something" be a lasting sense of safety or an emotional/spiritual connection which occurred during the creative process?' Even if a person with dementia has completed a product or end result in the art process, he/she may not retain the memory of the process and connect to the end product. In fact, immediately after completion and even at times throughout the creation of the artwork the person might be uncertain

of whether or not he/she was involved in its conception. I have hung a person's artwork in his/her room, which was later thrown away. Seeing a piece of artwork that may be abstract or unrecognizable, yet signed by the person with dementia, may be upsetting to certain participants. Art therapists must consider the emotional response a person has for his/her own artwork after the session. I often find it more beneficial to ask to keep people's art in a portfolio, rather than to display it in their rooms, unless they ask to keep an image. I place more investment and intention in 'holding a space' for the creative process than investment in an end product. For persons experiencing short-term memory loss, developing memory retention may be an objective of the art therapist. It is known that people have a kinesthetic and soulful memory of such things as a caring touch or a connection or bond with another, which must be weighed just as heavily as remembering the group theme or recognizing a finished product as being one's own.

EVALUATION

Signs of organicity or disease processes affecting bodily organs, in this case the brain, may be evidenced in the art products of those with dementia. Such signs may include indistinct perseveration. Cronin and Werblowsky (1979) describe this subtle perseveration: 'The same lines, shapes, or configuration reappear from drawing to drawing. In gross organicity, perseveration means the mechanical repetition of forms on the same drawing' (p.105).

Mrs. A, an 82-year-old woman, drew figures and faces regardless of the art directive. However, their identity and the dialogue associated with them varied from session to session. She identified the figures as little boys, little girls, herself and her husband. She sometimes described the images as 'little people walking to school' and that 'this one is chasing after

that one'. Mrs. A began by drawing only facial profiles, then moved on to include legs in the images (Figure 1.1). Finally, she drew figures that included heads, arms, legs and torsos (Figure 1.2). Mrs. A shared of her love of drawing and often talked about her husband who lived away from her. She stated: 'I just accept it and hope it will be different in the future, but right now I'm doing well and I enjoy my life here'.

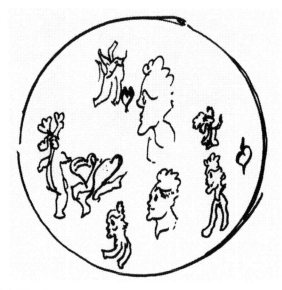

Figure 1.1. Mrs. A

A further sign of organicity is described by Cronin and Werblowsky (1979) as short, picky lines: 'The patient drew in a stop-start, slow, tedious fashion, and with his pencil he seemed to pick at the paper instead of drawing clear, deliberate lines' (p.104). Mr. E drew an image (Figure 1.3) using multiple colors, later pointing out that the almost indiscernible figure enmeshed within the short black strokes of the marker was his wife.

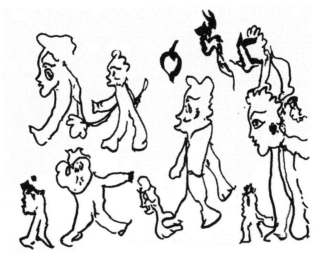

Figure 1.2. Mrs. A

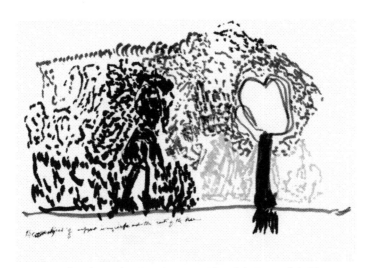

Figure 1.3. The Subject of Support are My Wife and the Roots of the Tree

When looking at the examples of artwork with evidence of short, picky lines, one must consider each person's experience via the process and product. For example, Mr. R was a man who

communicated much through gesture and rhythm. Mr. R communicated by hitting the table with intentional cadence using a spoon or his palms, clapping his hands to his own tempo and moving his arms in the air with control and method. His experience in art therapy, which included making short, picky lines (Figure 1.4), was therapeutic in that he gained a response from his peers and therapists, who drew in the same manner and rhythm as he. His affect and verbal contributions reflected a sense of control over his environment, mastery and achievement.

Figure 1.4. Mr. R's Strokes of Green

Figure 1.5. Mrs. P's Christmas Tree

In contrast, one woman who made short, picky lines looked at them with dismay (Figure 1.5). Was she dismayed due to an awareness of changes in her cognitive status and skill or did her past lifestyle and career demands mandate a discriminating attitude and precision? She now becomes frustrated at times but accepts and even welcomes the challenge of the creative process.

One must look at many factors to know when the process of making art, even making short, picky lines, is no longer beneficial for a person. I always rely on a person's facial and bodily affect as the best indicators of where and when therapeutic goals require re-evaluation. This is not limited to acute situations in which using a more or less controlled medium might relieve anxiety or frustration with a certain type of art material. Over a period of time, the therapist can form an opinion from someone's affect as to whether the continuation of art therapy is beneficial to the individual or not. Perhaps another modality, such as music therapy or dance/movement therapy, or art therapy in collaboration with another modality, would better meet the person's need and promote their remaining strengths.

The appearance of a piece of artwork and its line quality may be the deciding factor in the art therapist's decision whether or not to continue offering art therapy. I would challenge each therapist to consider the existential issues addressed and therapeutic benefits gained by making even slight markings or producing a seemingly unrecognizable jumble of colors. In person-centered care, it is unlikely that I would take a different approach to artwork exhibiting picky lines or perseverative qualities than an art therapist working with a different population, such as well teenagers. A teenager's image exhibiting picky lines or perseveration may be evidence of comprehension difficulties or brain damage, though these qualities could simply represent an expression of artistic style

or emotion rather than difficulties in comprehension or signs of brain damage. The same would apply for one with dementia (Figure 1.6).

Figure 1.6. Anger

Figure 1.7. Abstract of Emotion: Love

Persons with dementia may paint in a style that takes on qualities of 'pickiness', yet these qualities may be in response to the rhythm of any background music, an abstraction of emotion

(Figure 1.7), or a painterly style of overlapping and blending of colors (Figure 1.8).

Figure 1.8. Green Turtle Key

In summary, one must take a person-centered approach in interpreting artwork created in the therapeutic process, leading to a determination of whether continued intervention will lead to the overall goal of enhanced well-being for any given individual. It is essential for the therapist to bestow 'unbiased attention' (Moon 1995) to the artwork produced, so that the interpretation of the work is based on the experience of the person creating it, rather than that of the therapist.

CREATING THE THERAPEUTIC ENVIRONMENT

Facilitating a sense of safety is an individual consideration on the part of the art therapist. In my sessions, placing a red art

cloth on the table has been a consistent attempt to create a sense of familiarity of place among the group members. Maintaining consistency in routine may help to decrease anxiety and help the individual to regain some sense of order and control over his or her environment (Tappen 1997, p.85). One person's safety may mean having the door open or being in a decentralized area. For another, it may mean having a private space with a closed door. While one person may become apprehensive to see paintbrushes on the table upon entering the room, another might be inspired at the sight of the color palette. Sometimes it is helpful to wait for the group to become familiar with the space and engaged in dialogue before introducing the art materials. Flexibility and compromise are necessary in creating a therapeutic group environment.

MEDIA AND TECHNIQUES

Creating the space, knowledgeable interpretation of artwork, and skillful processing of psychological and existential issues acknowledged in the artwork are key elements in the recipe of the therapeutic milieu. The art therapist must also consider the physical safety of the residents and the preservation of autonomy when choosing the type of media or art materials to be used. Confusion in persons with dementia creates risks in using art materials, such as eating paint, pastels, etc. Being observant and using common sense may avoid serious and humiliating situations for the person with dementia.

Of course, the best intentions and awareness of the therapist may fail due to human error in which one may then look at circumstances surrounding the incident. For example, on one occasion the art therapy group took place in an open area of the home, due to the usual therapy room being unavailable. The open area consists of small tables that are commonly used for socializing, activities and dining. Prior to this incident, one

woman had not shown evidence of agnosia in art therapy. Agnosia is the inability to perceive or recognize things as they really are. In this case the woman misperceived the paintbrush for a utensil and placed it in her mouth. The situation was approached gently and the woman was successfully redirected with respect and integrity. Upon later evaluation, time, space and the woman's recent decline in cognition were considered to contribute to the incident. The fact that the dining room table was being used as a therapeutic art group setting and that the activity took place close to meal time increased the probability of her misperception of the media for food. To avoid serious consequences when working with persons with dementia, the art therapist should use non-toxic media and must be able to redirect individuals at a moment's notice. Media such as watercolor paint, tempera paint, oil pastels, chalk pastels, and scented markers are all available as non-toxic art materials. In addition, the therapist must consider possible associations between the group space and other unrelated events, such as meals.

The art therapist must ensure not only the physical safety, but also the psychological safety of each person within the group setting. The art therapist should choose appropriate media that is best-suited for the person, while considering issues of control and promoting autonomy. In order to accomplish this it is important for him or her to utilize techniques and art materials that do not outpace the person's abilities (Kitwood 1997). For example, in the technique of monoprinting or stamping, persons with dementia may feel successful and autonomous participating in certain steps of the stamping process. For one person, choosing the color, dipping the brush into the color, painting the stamp and printing it on the paper can be accomplished with a sense of autonomy. For another, choosing the color of paint, having the painted stamp handed

to him/her, then printing the stamp is done with a sense of autonomy. There are numerous variations in carrying out this technique. It is the responsibility of the therapist to determine which best suits the person's needs and preserves his/her sense of dignity and independence.

PERSON-CENTERED ART THERAPY: MEETING BASIC NEEDS

From evaluation, how does the art therapist support someone in the acknowledgement and resolution of emotional issues? How does art therapy provide opportunities for the fulfillment of needs of the person with dementia?

Love

It might be said that there is only one all encompassing need – for love…people with dementia often show…a generous, forgiving and unconditional acceptance, a wholehearted emotional giving, without any expectation of direct reward. (Kitwood 1997, p.81)

The therapist offers the same unconditional acceptance, wholehearted emotional giving and receiving, without expectation toward the person creating art. This includes a non-judgmental approach regarding color, application of media, and theme. Validation theory rather than reality orientation is also part of this approach. Moon (1995) stated, 'We must always approach the work of our patients with a sense of awe and reverence for the story they have communicated through their art' (p.111). In attempting to provide opportunities to meet the fundamental psychological needs of the person with dementia, art therapists may shed light into the 'dark picture of dementia'.

Figure 1.9. Garden of Love

It is important to provide a safe environment for the person with dementia to express feelings of romantic love. Mrs. E painted an image of a 'Garden of Love' (Figure 1.9). This woman frequently expressed feelings of romantic love she had for a man. This love emanated through and out of her whole person and was seen as a glow in her face and sparkle in her eye. Kitwood (1997) addressed the need for love and comfort, 'The heightened sexual desire that is felt by some people with dementia may be interpreted, in part at least, as a manifestation of this need' (p.82). Mrs. E's expression of love and sexual desire was evident in her art process as seen in her picturesque and brightly colored images.

Another resident used his gift of poetry and verse to express his romantic feelings and to offer love and comfort to his wife (Figure 1.10). He wrote the poem in his journal called 'Fantasia'. He requested that I read the poem to his wife who

resided in another area of the facility. This fulfilled Mr. A's wish to give comfort to his wife and met Mrs. A's need by receiving affection from her husband indirectly.

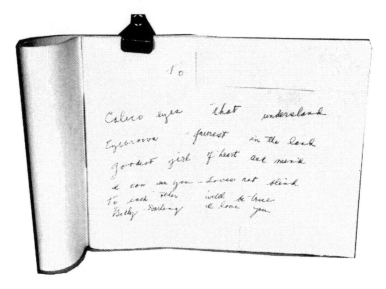

Figure 1.10. To Mrs. A

Text reads:

> *'Calico eyes that understand*
> *Eyebrows fairest in the land*
> *Goodest girl of heart and mind*
> *I can see you – loves not blind*
> *To each other we'll be true*
> *Betty, Darling I love you'*

Comfort

Kitwood (1997) defines the need for comfort:

> 'This word, in its original sense, carries meanings of ten-
> derness, closeness, the soothing of pain and sorrow, the
> calming of anxiety, the feeling of security which comes
> from being close to another. To comfort another is to
> provide a kind of warmth and strength, which might
> enable them to remain in one piece when they are in
> danger of falling apart. In dementia the need for comfort is
> likely to be especially great when a person is dealing with
> a sense of loss, whether that arises from bereavement, the
> failing of abilities, or the ending of a long-established way
> of life.' (Kitwood 1997, p.82)

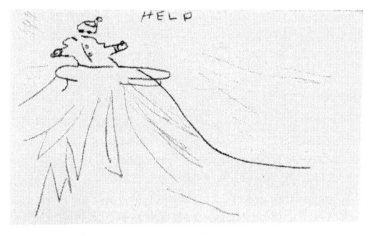

Figure 1.11. Help

Mrs. G. attended an art therapy group that had the theme of
winter/seasons. She drew a snowman on top of a 'plateau'
(Figure 1.11). She used only the color blue. As Mrs. G. was
drawing, she narrated a story from her imagination. She said,

'He (the snowman) was struggling all that time. This is a long, long, long struggle in the winter (referring to climbing up the mountain). Finally, he reached the plateau. And then he didn't know where to go or what to do. He was looking around. He says, "What am I going to do? The first thing I'm gonna do, I'll make a snowball, a nice snowball and throw it. There is nothing else to do." Then the wind starts to blow. He's got his hands out and he says "Here I am Ma!"' Mrs. G titled the image 'Help'.

In this group I asked the residents to hold out their hands like the snowman in Mrs. G's picture. Then I asked them how they felt. Mrs. E and Mrs. N said that the feeling reminded them of needing something or waiting for something. Mrs. E said, 'When I fall, I want someone to catch me and straighten me up.' Another resident said, 'Help me, Lord!' Each person in the group was able to give and receive comfort, while empathizing with the image through dialogue and movement.

Identity

'To have an identity is to know who one is, in cognition and in feeling' (Kitwood 1997, p.84). A technique that I have utilized in art therapy is the creation of feelings boxes (Figures 1.12, 1.13 and 1.14). Six pieces of white board are used as the 'blank slate' for feelings to be expressed through color, line and shape. (For more details on making the box, see page 46.) In the initial session, the group was asked to name six emotions. Each session addressed one emotion. The directive was for each person to add a color, make a line, draw a picture, or write a word that expresses the emotion. The board was passed from person to person until each member of the group that wished to contribute did so.

Honoring each person's image, color, line and/or verse took place during the creative experience. Many of the psycho-

logical needs Kitwood mentions were met through the group connection and sharing of life experiences inherent in this technique. This process was repeated for each emotion until each of the six sections of board displayed a feeling. One session per week was devoted to the feelings box. At the conclusion of the six weeks, the feelings box was assembled to form a three-dimensional cube. In current sessions, the feelings box is sometimes used as a transitional object to begin art therapy sessions and to provide opportunities for emotional reminiscence as I ask the question, 'Would you like to share a time when you felt love, pride, jealous, sad, angry, etc.?' This technique may then be used as an introduction and theme for individual images or to create an individual feelings box.

Through the feelings box, Mrs. G expressed a wide range of feelings including sadness. She would state, 'He'd bring me ice-cream when I was sad. And now I don't have him. I always think he's with me, that keeps me going.' She also expressed love, saying, 'Love is happiness. I'm always happy, what does that mean (pointing to her head)?'

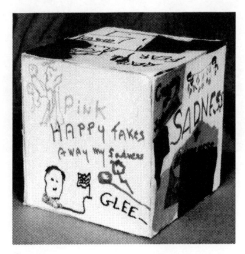

Figure 1.12. Feelings Box

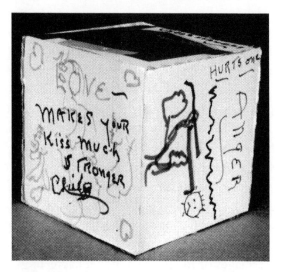

Figure 1.13. Feelings Box

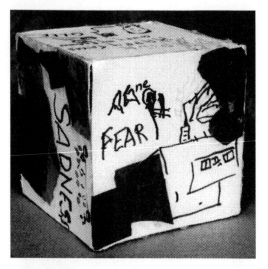

Figure 1.14. Feelings Box

Inclusion

Kitwood addressed the need for inclusion by saying,

> If the need is not met a person is likely to decline and retreat, until life is lived almost entirely within the bubble of isolation... When the need is met, a person may be able to 'expand' again, recognized as having a distinct place in the shared life of a group. (Kitwood 1997, p.83)

The very nature of group art therapy seeks to satisfy this need for inclusion. In addition, using a person-centered approach, the art therapist may adjust the art task to correspond to the strengths of each person. For example, a group may consist of people with various cognitive and fine motor abilities. A mixed media piece of artwork (Figure 1.15) was inspired by the theme of autumn. Mr. B felt comfortable with the spontaneity of painting on a blank sheet of paper and painted a shagbark

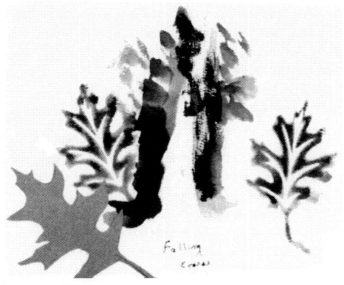

Figure 1.15. Falling Leaves

hickory tree in the middle. Mrs. H, who had more severe cognitive impairments, was offered a leaf stamp and was successful at choosing a color and painting the stamp with cueing provided by the art therapist. She then printed the stamp on the paper. Mrs. S, who was a nurse and enjoyed detailed needle working in the past, was successful in tracing a leaf on colored paper, cutting it out with scissors, and gluing it onto the paper. The art therapist, knowing a person's strengths, may adapt and adjust the art therapy task to most fulfill basic psychological needs.

Attachment

Kitwood's description of attachment (lecture 1998) as 'how a person expresses affection, friendship, passion, and bond (familiarity to environment and people)' has a distinct role in the art therapy group process. Attachment often occurs in the group art therapy setting through the course of identifying emotions and sharing images and life experiences among peers. Feelings of security, emotional validation, and assurance have often developed through group art therapy due to common life issues (generational, emotional, situational, physical, and social) of the group members.

Tappen (1997) wrote on factors related to depression of persons with Alzheimer's disease, saying:

> Compounded with an increasingly restricted lifestyle, the isolation that can occur when friends and family withdraw, inability to reciprocate in the give-and-take of personal relationships, and discrediting by self and others results in a substantial list of psychosocial factors that may contribute to the development of depression. (Tappen 1997, p.84)

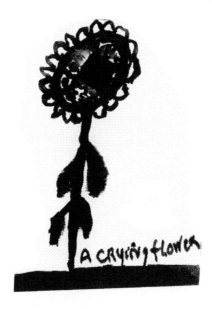

Figure 1.16. A Crying Flower

A woman painted a flower (Figure 1.16) in colors of green and red entitled, 'A Crying Flower'. Feelings of sadness were well hidden by her social grace. She was a woman who was extremely conscious of her external impression. She was always well dressed, her appearance enhanced with a great deal of jewelry and make-up. Her hair was always impeccably styled, and she was always prepared with a welcoming smile. The combination of red and green, however, which may be referred to as 'colors of crisis' (Cox 1999) and the wilted leaves reflected her inner state of sadness. Mrs. M's title and dialogue about her image confirmed this state of sadness. From the time Mrs. M acknowledged her feelings of grief and loss, her peers offered support through testimonies of their own experiences of grief and personal coping styles. One woman stated that after her husband died, spending time with other people gave her comfort when she felt lonely. Others shared their spiritual

beliefs, offering the suggestion of prayer in times of loss. Still another individual discussed finding solace by reading books.

Occupation

Kitwood (1997) defined occupation by stating, 'To be occupied means to be involved in the process of life in a way that is personally significant, and which draws on a person's

Figure 1.17. My Hopes and Dreams

abilities and powers' (p.83). Art therapy can enhance self-esteem and provide a space for persons to be '…occupied in relaxation or in reflection' (Kitwood 1997).

The abstract watercolor painting depicted in Figure 1.17 reflects one woman's existential theme. Mrs. E used line, shape and color to express her notion of hopes and dreams, and her

creative process was very reflective of these feelings. Mrs. E was highly focused and painted with intention and sincerity. One could almost see her hopes and dreams through her facial expression. Upon completion of the image, Mrs. E placed her hands over her heart and sighed. She stated how happy she felt and expressed joy at seeing her image matted on a colored piece of construction paper.

Kitwood (1997) also discussed the need for occupation in terms of people who 'want to help or take part'. I often invite residents to help in the process of setting up the space, which can include filling water tubs, smoothing out the art cloth, and setting the art materials on the table. This practice meets the needs of both the therapist and the resident.

HIGH EXPECTATIONS

Expectations exist on three levels in the practice of art therapy with persons with dementia. These can include expectations of the participant, the staff and the therapist. The terms 'art' and 'therapy' produce similar reactions in many people. Early in my professional experience, I struggled with how to describe the art therapy group. As I wanted to distinguish between therapy and activity, I made signs saying, 'Art Therapy in Session.' In some cases I found it necessary to become a barrier between people and the signs, when guiding people through the door. When some residents read the signs, they would change their minds, saying 'I am not an artist' or 'I don't need therapy'. Just the word 'art' can cause people to look away, laugh nervously, or say, 'You've got the wrong person, honey!' Cultural, societal and personal expectations can inhibit people's sense of safety in expressing themselves through a creative modality.

I soon found that the words used and the manner in which the invitation is extended to be the deciding factors in whether or not a person attends therapy. To avoid the immediate reac-

tions, including negative self-talk and societal stigmas, I now invite the person to 'spend time with me in a small group'. At times people ask the purpose of the group and I state, 'To get to know each other better and to express our feelings'. Depending on the cognition of each individual, I might ask, 'Would you like to stand up?', 'Let's walk together' or 'Let's walk to the group room'. Once a person arrives in the space, it is always explained, 'I am going to invite someone else to join us. Will you please wait here for me?' If they are comfortable, I state, 'I will be right back'. At times, I am able to stay in the room as other staff assist residents to the room.

Once the group gathers, I introduce myself by name and invite each person to say his or her name. For persons with more severe cognitive impairments, I find it helpful to approach each person individually. While touching their shoulders, I say their name and welcome them. After each person's name is spoken, I ask how he or she is feeling. Some answer 'Fine, thank you' or 'Tired'. Some show a facial expression or posture that expresses their emotion. These visual indications are reflected back to each person. After the introductions, I give a brief explanation of art therapy and my expectation, saying, 'My name is Holly and I have brought art materials to help us express ourselves. We express our feelings through words. We can also express our feelings through color. We do not have to be artists to draw or paint. There is no right or wrong.'

We often start with a theme. I say, 'I will suggest something to draw, paint or think about, but if you already know what you want to do that is fine. You can simply put lines, shapes or color on the paper. You can draw a flower or a tree.' I suggest that the person may want to explore the way the brush moves on the paper or how the colors blend together. I have seen much spontaneity and courage from persons with dementia. For many the

hardest part of the creative process is getting started. There-
fore, I usually begin with the choice of color, setting out a
variety of different colored markers (the number of markers
depends on each person's ability to make discriminative
choices) saying, 'What color do you feel like today?' This
question, although abstract in nature, is almost always
answered, either verbally or nonverbally. From this point, I
may get an idea of the emotional state of the person, as color
does reflect emotion. Then I will use techniques such as verbal
cueing and visual modeling. I might also help an individual
begin the process by holding my brush close to theirs, placing
it in the water, moving it around in circles and so on from
there. I believe strongly that as much as possible, the person
should be encouraged to create and make the choices. This
provides a more pure reflection of the person's emotion in the
artwork.

TREASURES OF THE HEART

Art therapy has much to offer in terms of providing opportuni-
ties for fulfillment of the basic psychological needs that
Kitwood described. Love, comfort, attachment, inclusion,
identity, and occupation are aspects of life that every human
being desires. For some people, masks of the ego may interfere
with giving and receiving these needs. Persons with dementia
have a transparency that can be a model for those of us who
have difficulty in our own self-expression. They have no masks
to wear and they maintain their emotional identity until the
very end of their lives.

The magnificence of being an art therapist with persons
with dementia is the certainty and almost necessity in
becoming emotionally attached to each person through the
relationship developed during the creative process. The oppor-
tunity to share honorable and heartfelt experiences as we

explore the accomplishments of each person's life is one for which we can be grateful.

SUGGESTIONS FOR CAREGIVERS

Art activities can be very enjoyable for both persons with dementia and their caregivers. Caregivers who have a clear understanding of the functional strengths and limitations of the persons for whom they are providing the experience will find that the process of completing art activities can be very successful. The following suggestions can be used to engage one or more persons at a time.

Feelings box

This project may extend over six sessions. You will need:

> 6 squares of sturdy white paper (poster board works well)
>
> index cards
>
> pieces of colored tissue paper
>
> scrap materials such as tin foil, materials, buttons, etc.
>
> markers
>
> hot glue or tape.

1. Have group members choose six emotions from a selection of approximately ten written on index cards. These may include happiness, sadness, anger, love, fear, pride, etc.

2. Ask each person in the group to express something about the emotion chosen (one emotion per session)

by adding a color, word, item or picture to the square paper.

3. Once each square is complete, adhere the squares together with hot glue or clear tape to form a cube or box.

You may then use the feelings box to begin future discussions. This can be accomplished by having a member of the group toss the box into the center of the table, providing an opening for the group to express reflections and experiences related to that emotion.

Group art process

You will need:

a sheet of white paper for the group to share (large enough for all to use, but small enough to pass between group members)

markers, paints, chalks or pastels.

1. Begin with one person adding a color to reflect his or her feeling (could be a favorite color).

2. Continue around the group until each person wishing to participate has an opportunity to add a color or an image.

3. Discuss the importance of each person's contribution, allowing others to respond to what is added each time.

Collage

You will need:

a sheet of white paper sized appropriately to either group or individual use

magazine images or calendar pictures of animals, nature, people, objects, etc, either already cut out or ready for participants to cut from their source

glue and/or tape.

1. Begin by having members choose (and cut out, if appropriate) images that reflect preferences, emotions, familiar scenes, etc.

2. Arrange the images on paper with glue or tape, encouraging participant(s) to make decisions regarding placement.

3. Encourage discussion and/or reminiscence surrounding the images chosen and their meaning for the individual choosing them. If using with a group, look for similarities and differences between the choices people make. Encourage awareness and appreciation of others' contributions in the group.

Chapter 2

Dance/Movement Therapy
Partners in Personhood
Liat R. Shustik and Tria Thompson

...the orchestration of the group members whose bodies, minds and spirits serve as instruments...our harmony and melody...each bar, each phrase added on and on...everlasting song and dance...room for all instruments to bring forth their rhythm...their tone...their moved and moving qualities...their being to this sacred space and to the universal choreography of our living and our dying...

The dance/movement therapy program at University Hospitals Health System and Heather Hill Hospital and Health Partnership involves the intentional and compassionate use of breath, movement, touch and dance to promote the physical, psychological, emotional and spiritual well-being of each person. Dance/movement therapy recognizes that 'the body does not lie' (Graham 1975). Each person's soul is expressed in her/his movement vocabulary. Each person's ability to access and

express feelings through the body remains until the last dying breath, no matter what physical or cognitive limitations exist.

As an intervention, dance/movement therapy has the potential to address issues of anger, loss, grief and abandonment. It allows for joy, human connection and celebrations of life. Though these issues and celebrations are often thought to be lost to those experiencing dementia, the use of dance/movement therapy is often able to make the connection once again, providing a new and possibly nonverbal method of expressing emotion, allowing work on issues and the integration of life experiences.

It is useful to begin this chapter by providing several definitions of dance/movement therapy. The American Dance Therapy Association (1999) states dance/movement therapy is: 'The psychotherapeutic use of movement as a process which furthers the physical and psychic integration of the individual.'

The Association for Dance Movement Therapy United Kingdom (2000) defines dance movement therapy as: '...the psychotherapeutic use of movement and dance through which a person can engage creatively in a process to further their emotional, cognitive, physical and social integration.'

Given our operating definitions of dance/movement therapy and the desire to apply its principles to persons with dementia, several questions can be posed. First, how does one dance into this life space? Further, how does one move into a space that may be filled with apprehension as well as issues of anger, loss, grief and abandonment? The key belief embraced by this modality and all who practice it is that this process should be approached with great respect for the dignity and beauty of each dancer's body and soul.

Fundamental to both dance/movement therapy and person-centered care is the belief that the therapist must meet people 'where they are' so as to refrain from outpacing anyone

(Espenak 1981, pp.101–102; Kitwood 1997). Also shared by the two is the relational framework of our existence in which 'even when cognitive impairment is very severe, an I-Thou form of meeting and relating is often possible' (Kitwood 1997, p.12).

PARTNERS IN PERSONHOOD

Kitwood thoughtfully contemplated the concept of personhood, reviewing its presence in discourses of transcendence, ethics and social psychology. Recognizing a basic conceptual unity, he arrived at a definition of personhood as:

> …a standing or status that is bestowed upon one human being, by others, in the context of relationship and social being. It implies recognition, respect and trust. Both the according of personhood, and the failure to do so, have consequences that are empirically testable. (Kitwood 1997, p.8)

Kitwood affirms that 'to see personhood in relational terms is …essential if we are to understand dementia' (1997, p.12). In his account of ways in which we can gain insight into the subjective world of dementia, Kitwood challenges us not to resort to mere intellectual understanding, but rather to embody and hence come closer to a more genuine 'standing under' (1997, p.79). Recognizing that such embodiment may be 'one of the most powerful routes to understanding' he further challenges us to explore 'feeling the shape and weight of things, knowing them in action rather than in mere reflection' (p.79). This kinesthetic 'standing under' is precisely what the dance movement therapist strives for in the initial process of forming 'recognition, respect, and trust' within the therapeutic alliance.

The application of dance/movement therapy to reaching such subjectivity with those living with dementia presents

special therapeutic considerations. Kitwood claims, however, that some sense of intersubjectivity is guaranteed by having a language that is shared. He contends that:

> Even more significant is the language of the body: expression, gesture, posture, proximity, and so on. This conveys emotion and feeling with great authenticity, and here we are coming close to cross-cultural universals. (Kitwood 1997, p.71)

Dance/movement therapy techniques may be likened to such a language. It is this 'language' of the body that dance/movement therapists utilize in the creation of movement dialogue/communication and the meeting of the core psychological needs of persons with dementia, which include love, identity, comfort, attachment, inclusion and occupation. The following is an exploration of these needs as they are approached through dance/movement therapy principles and techniques.

IDENTITY

It is known that people have a kinesthetic awareness and that this internal sense of our physical self may be awakened, encouraged and developed, regardless of cognition (Levy 1992). In the advent of short-term memory loss, confusion and an eroding sense of self, it is a primary objective of the dance/movement therapist to aid in accessing the memory/ awareness held in the body, thus facilitating the maintenance of a sense of identity. This may be addressed in various ways and varying levels depending on what is presented to the therapist.

Mrs. C was often seen repetitively tapping her body parts with her hands. At times she did so incessantly and with a look of anxiety as seen in her facial affect and gesturing. Furthermore, Mrs. C appeared to be removed from her environment, as evidenced both by her physical distance (spatial orientation) and a lack of interest in and interaction with others. Her head and shoulders were hung and her eyes focused downward. Approaching Mrs. C carefully and with reverence for her space, I initiated eye contact. At one point, I sensed the invitation to move in closer and join her in her movements. We initially tapped our own body parts. This developed into a playful and spontaneous tapping of one another's body, exploring different rhythms and patterns. As we exchanged spontaneity and wit, Mrs. C appeared more elated, as evidenced in her smiling and laughing, and a newly found sparkle in her eyes. Mrs. C held my hands and led them in the guided tapping and stroking of her body. As we developed a consistent rhythmic pace, Mrs. C exclaimed, 'This is me. Here I am.'

It is important to wait for permission, whether verbal or kinesthetic, to reflect the movements of an individual, as people differ in their responses to this reflection of their emotional status. Such approval may be detected in eye contact, intuitive sensing, and recognition of facial affect and bodily movement. This exchange, resulting in permission, is crucial to creating an experience of therapeutic mirroring as distinguished from perceived mimicry. Mirroring involves coming in contact with, on a visual and kinesthetic level, that which another is experiencing, then communicating it back with matching muscular activity and affect. This manner of mirroring, developed by Marion Chace (Levy 1992) is also referred to as kinesthetic empathy or empathic reflection. In the environment of dance/

movement therapy, mirroring promotes a sense of being 'seen', met and understood, thus recognizing and celebrating the inherently relational identity of a person. Mirroring is utilized here to honor the uniqueness of each person. While at times mirroring may include literal reflections of one's body language and affect, it may also be met with other elements such as music, humming, tone and rhythm.

Creativity, spontaneity and play all interweave in the awakening of one's zest for life, thereby promoting a more positive sense of well-being. Furthermore, spontaneous and playful movement dialogue may promote a sense of autonomy, as individuals have the opportunity to initiate and create effects in the environment.

The use of rhythm and/or rhythmic movement relationships may be effective in organizing the expression of self, specifically when fragmentation and confusion may be present. 'Even severely withdrawn patients could be mobilized by the contagious aspect of rhythm, with safe and simple rhythmic sequences providing a medium for the externalization of otherwise chaotic and confusing emotions' (Levy, p.26). Indeed, here the power of rhythm may be seen as a contributing factor to Mrs. C's shift from an internal focus to that of the external environment. Rhythmically tapping one's body provides assurance of presence and identity in one's relational environment. This is one example of the effect of tactile stimulation.

Gender and identity are intimately linked in the human person. From our birth ('is it a boy or a girl?') our bodies hold our identity and all the issues pertaining to it, including sexuality. Often gender issues and sexuality are downplayed in the later years of life and especially in persons with dementia. Dance/movement therapy provides the opportunity to work with these issues through attention to bodily movement, interaction, sensations and needs. Sandel (1979) noted that group

movement therapy sessions provide the supportive environ-
ment where touching, the expression of memories and the
sharing of feelings, both verbally and nonverbally, can be
experienced. Such expressive experiences support person-
centered care and enhance the personal identity of the partici-
pant. Dance/movement therapy may be one of the few places
that persons with dementia have the opportunity to express
and explore their sexuality. In this regard, dance/movement
therapists have a unique opportunity to work with the concept
of identity.

When awareness of the here and now of physical existence
is intact, the technique of role-playing may be employed.
Role-playing provides an opportunity for embodiment of past
and present roles, thus offering the opportunity for 'having a
sense of continuity with the past: and hence a "narrative", a
story to present to others' (Kitwood 1997, p.83). The kines-
thetic expression of these roles often opens channels of verbal
reminiscence as well; accessing the body's memory of feelings
may lead us into and move us toward storytelling and/or ritual
expression (Stockley 1989, p.85).

In this case tapping into life roles through the body exem-
plifies one way of facilitating one's ability 'to know who one is,
in cognition and in feeling' (Kitwood 1997, p.83). Hence,
role-playing and reminiscence through movement may also be
utilized in the advent of integrating an individual's sense of
identity. As Kitwood suggests, a sense of personhood relies
heavily on personal relationships. Hence, it is not merely
feeling one's identity that satisfies this need, but rather, identity
coupled with social validation.

As the therapist and/or group members reflect or 'try on'
one another's movement, exploring how it feels to move in that
manner, kinesthetic awareness and validation are likened to
one's ability to make a 'subjective connection' (Levy 1992).

This is where the dance/movement therapy session offers a cyclical manner of reaching the individual and collective relational identity otherwise known as connection. It is within the realm of this interconnectedness that relationships may develop. These connections and relationships lead to the fulfillment of the need for attachment.

ATTACHMENT

The dance/movement therapist facilitates kinesthetic connections between persons in the group, thus fostering and modeling communication and opportunities for attachment between group members. This empowerment (aiding in increased self-esteem, trust and affection) allows each person to reach out affectively and form kinesthetic attachments at psychic and spiritual levels. It is not uncommon for the person with dementia who has been in dance/movement therapy groups with the same therapist and peer group to express feelings of closeness to and knowing of those members.

Instinctively, as one woman enters the sacred space, she smiles at other group members and exclaims, 'We've been here before, haven't we?' A man who rarely verbalizes coherently within or outside of the group atmosphere states, 'We've been through a lot together'. Each of these attests to a sense of kinesthetic bonding and attachment.

Attachments create:

a kind of safety net, particularly in the first years of life, when the world is full of uncertainty. Without the reassurance that attachments provide it is difficult for persons of any age or ability to function well. The loss of primary attachment undermines the sense of security, and if several bonds are broken within a short time the effect can be devastating. There is reason to suppose that the need for

attachment remains when a person has dementia: indeed, it may be as strong as in early childhood. (Kitwood 1997, p.82)

Mrs. L was found calling out 'Mommy...I want my Mommy' while rocking in her seat. Mrs. L approached me and initiated a choreography of hugging and swaying. As we both moved, Mrs. L stated, 'I love you'.

The calling out for one's mother may be seen as a yearning for attachment to, as well as security from, one's environment. This attachment to and safety from the environment is hopefully experienced initially in this world with mother. Feelings of fragmentation and confusion often all too common for persons with dementia, and frequently seen in their movement qualities, may compound the yearning for wholeness and for literally being 'held' together. Furthermore, with the decline in memory and hence eroding sense of self, the person with dementia may experience difficulty in the ability to image the internal caretaker, 'a necessary prerequisite for self soothing' (Johnson, Lahey and Shore 1992, p.270). Recognizing this, the dance/movement therapist utilizes various techniques to promote the sense of security and safety the person may be seeking.

The first symbiotic bond and attunement is experienced with mother and is the basis through which relationships develop over a lifetime. Furthermore, this symbiosis and attunement are first exchanged nonverbally. The intrapsychic experience develops from nonverbal exchanges occurring between mother and child. Over time, the relationship deepens and the child begins psychic and kinesthetic differentiation between self and other, attachment and detachment. This expe-

rience serves as a base through which future relationships are approached, as occurred with Mrs. L. Winnicot (1965) refers to this relationship as 'good enough mothering'.

In interaction with Mrs. L, the therapist may be seen as the object on which projection of mother was placed. It is not unlikely for the therapist and/or group members to become the nurturing, holding and comforting container. Often in our experience with persons affected by dementia, we see the emergence of the archetypal mother. This theme may appear in dual-fold, at times as that of being mothered and nurtured, while at others taking on the role of mothering and/or both. Consequently, the therapist may find herself role-playing the mother at one instance and child at another. Further, the experience is as different for each individual as each person is unique. For example, one woman holds the therapist with great joy and satisfaction, while another grieves the loss of her role as woman and mother, stating that she is no longer able to 'help the children who need me'.

A person with dementia may have the need and the ability 'to nurture and to express compassion toward others…by attempting to comfort those in distress' (Johnson et al. 1992, p.273). The opportunity to do so within the social context and safety of the group fosters feelings of warmth and contribution, hence focusing on the ability to give love, which often remains intact. While a person with dementia may frequently feel dependent upon others, the opportunity to offer nurturing highlights an individual's strengths and gifts, thus fostering a sense of autonomy.

In addition to physical holding, attachment may be expressed in dance/movement therapy by touch, breath, eye contact and the formation of dyads. Furthermore, the use of transitional objects is given meaning and purpose, both practical and imaginative. Transitional objects, like the stretch cloth,

provide an object onto which persons can project feelings and imagery. On a basic level the stretch cloth can organize and structure movement by concretely connecting/attaching the members to one another in a similar rhythm for the purpose of exploring and responding to group and individual issues. Moreover, attachment is symbolically born out of the 'active imagination'. Here, our notion of one's core needs, in this case attachment, may be greatly expanded and paralleled in the realm of transcendence.

In introducing movement with a stretch cloth, each member of the group grasps hold of the material. As movement emerges in a matching or clashing manner, the cloth reveals a representation of group dynamic and/or attachment/detach-ment. In one session, the group moved together, eventually coming to a point when unity and connectedness was felt and seen in the movement and flow of the rising and falling cloth. Further, a marked shift in the energy of the group was felt kin-esthetically and seen visually. This continued in silence for a significant amount of time until one woman, breathing deeply and appearing elated stated, 'I feel like I'm flying...like I'm a bird'.

The symbol of a bird has been called a symbol of transcen-dence. Jung (1964) explains that symbols of transcendence 'point to man's need for liberation from any state of being that is too immature, too fixed or final'. In other words, they concern '...man's release from or transcendence of any confin-ing pattern of existence as he moves toward a superior or more mature stage in his development' (Jung 1964, p.146). Was this woman experiencing, even if just for the moment, liberation from and 'flying out' of the neurological confines of dementia?

More specifically, Jung explains the bird as representing 'the peculiar nature of intuition working through a "medium", that is, an individual who is capable of obtaining knowledge of

distant events or facts of which he consciously knows nothing, by going into a trancelike state' (p.147). One cannot ignore Jung's associations as being, in this case, exceptionally appropriate for this woman's presenting life issues.

Something to keep in mind when using such objects is that they may or may not facilitate the development of attachment. Indeed, it is essential to remember that both merger and separation are equally important aspects of human existence. In fact, separation is integral to the development of a healthy sense of merger. More importantly, in utilizing transitional objects, the therapist must resist the need to have objects necessarily create bonding and unification between or transcendence of the group members. The therapist does not make attachments. She only provides opportunities for such via introduction of transitional objects, modeling and holding a safe space. People form attachments, which may then foster a sense of security, warmth and comfort.

COMFORT

The state of comfort is explained by Kitwood as a word which, 'in its original sense, carries meanings of tenderness, closeness, the soothing of pain and sorrow, the calming of anxiety, the feeling of security which comes from being close to another' (1997, p.81).

Exhibiting a widening, opening movement of the upper body cavity, generally reflective of feelings of fullness and joy, Mrs. B expressed that she was grateful for her children. With the exception of Mrs. A the rest of the group mirrored her movements and attested to the love they felt for their children. One women added, '...but boy I don't miss childbirth'. There was laughter followed by quiet moments spent swaying and expressing

through movement and touch (i.e. reaching across the circle towards another group member) in which connections and attachments were made. Mrs. A began an upward reaching movement, generally reflective of a desire to reach something unattained or that one feels may be 'a far reach'. Other group members began mirroring this movement and the therapist asked what each was reaching for or what one thing each desired in her heart. One woman said that she was reaching for the stars. Mrs. A, who had remained emotionally distant from the group in past sessions, said to the therapist:

Mrs. A:	Guess what I'm reaching for?
Therapist:	Connection?
Mrs. A:	Well, yeah, but to what?
Therapist:	Is it to a feeling, like love?
Mrs. A:	Yeah, but to what?
Therapist:	Is it to a special person?
Mrs A:	(With tears forming in her eyes) Yes, to the baby I always wanted.

Mrs. A then shared her lifelong desire to have a baby but stated that this had not been possible for her and her husband.

Mrs. A was able to tearfully express to her husband her feelings of guilt, sorrow, shame and frustration at not knowing the cause of the problem as well as their inability to communicate with and support each other through the pain. The comfort provided by the group and Mrs. A's acceptance of this support were phenomenal to witness. Mrs. A's body attitude shifted as she continued to address her husband. There was a release of muscle tension, widening of the chest cavity and lengthening of the torso, all of which are generally associated with gaining a fuller sense of self. Furthermore she seemed to reach a place of forgiveness and acceptance of herself and her disappointments as heard in her

verbal sharing and seen in her initiation of deep breathing and nurturing movement.

As closure approached, the group held hands, moved and vocalized in unison in a manner that seemed to reflect the birthing process on a metaphorical level. This was acknowledged and as a group, all raised their arms in the air. With a squeeze of hands accompanied by a sustained, descending vocal 'ah', they released hands and lowered their arms. The group members served as midwives to the birth of resolution and forgiveness as well as a new depth of group cohesion that had taken place through movement.

Comforting, honoring and 'seeing' one's identity in the way described above allows room for one to be a contributing member and hence begins the fulfillment of the need for inclusion.

INCLUSION

As the strengths of a person are honored and celebrated, he or she 'may be able to "expand" again, recognized as having a distinct place in the shared life of a group' (Kitwood 1997, p.83). Certainly, as there are persons with varying levels of progression of disease, so too are there varying methods for inclusion. Different methods in dance/movement therapy may be utilized to support the inclusion of different group members.

For persons with dementia special considerations of group dynamics have to be taken when addressing the need for inclusion. Allowing for permeable group boundaries and the ability to leave the group are two such considerations.

Persons who often remain physically outside the group may gradually become part of the circle and even enter the center safely. Statements such as 'We've been here before' show

evidence of increasing levels of trust and comfort both between group members and with the modality. A man who expressed initial hesitation at expressive movement is found exploring expressions through his body with ease, while another simply approached by the therapist states, 'What are we going to do, dance?' A woman dances towards the therapist as she sees her enter the unit.

Once inclusion is felt, a person may explore different levels of involvement (also promoting inclusion) within the group structure and the communal spirit.

OCCUPATION

Occupation entails being 'involved in the process of life in a way that is personally significant, and which draws on a person's abilities and powers' (Kitwood 1997, p.83).

> During a warm-up Mrs. E began to share her thoughts, 'I used to be active...to move'. As she led the group in reminiscent movement paralleling her past activities, she named them. 'I used to run and swim a lot. Now I walk a lot.' Indeed, Mrs. E was usually seen walking alone and was generally 'too busy' to join the group. While she was clearly involved in her sharing, Mrs. E was aware of other members as evidenced by her noticing and assisting another woman in her attempt to move to another chair. When the therapist acknowledged her attentiveness, Mrs. E stated, 'Doing for others helps me not feel lonesome'. She continued to reminisce about how she led her life that way in the past, speaking of her past occupation as a social worker. Her past role of helping others extended to her remaining and ever-present ability to support others in the group. Mrs. E then initiated group discussion, asking, 'How about everyone else...what did you do?' The themes of occu-

> pation and loneliness were developed. 'Helping others',
> as Mrs. E put it, aids the feeling that there is meaning to a
> person's presence. 'You're doing something important,
> like now (sharing in group process).'

Person-centered dance/movement therapy is primarily impro-
visational. A word that is used often is 'explore', as are state-
ments such as 'What would it be like to: move a body part;
show something you like to do; imagine'. Dance/movement
therapy sessions are creative work/play. It is 'work' or occupa-
tion in the present. Making movement stories using 'props' and
ritualizing needs, wants, fears, hopes and desires is the creative
occupation of those persons gathered. To quote a participant,
'You invite us to come. We don't always want to, but something
always happens'.

After exploring the word 'push' with hands, feet, furniture
and a table drum one day, many group members made
comments about the work they had accomplished. One person
stated, 'Pushing feels good. I feel strong pushing'. Another
stated, 'I don't like to be pushed'. One woman began crying
and talked about being 'pushed out of the house' to go to a
workplace she didn't want to go to. Stories about work and
movement about work then emerged with members showing
how to make bread, feed horses, ride a bicycle, fly a plane and
the like. The 'work' developed into what might be called
role-plays and included all group members showing and dis-
cussing this, making comments such as, 'My mother taught me
to make bread this way'. To this, one man responded, 'Oh, I
just ate it and it sure tasted good!'

As the time for exploring pushing drew to a close the thera-
pist asked the group for their thoughts on how they might end
the session. One man stood and started to push his chair back
saying, 'Let's push the chairs back'. Other members got up and

started following his example. Two women moved the table drum together. Members spontaneously began thanking each other, smiling and shaking hands, talking about the 'good work we did here'. People accompanied each other out the door. All had been included in creative occupation.

LOVE

The five aforementioned needs overlap, merging together in the core universal need for love. Kitwood (1997) states: 'Persons with dementia often show an undisguised and almost childlike yearning for love...a generous, forgiving and unconditional acceptance, a wholehearted emotion giving without any expectation of direct reward' (p.81). This beautiful, authentic love is offered through the connections made and shared in the work of dance/movement therapy. In this work and the relationships formed through it, persons with dementia challenge caregivers and therapists alike to explore their own authenticity – who they are when not wearing their 'masks'. The language of the body and the kinesthetic realm open a higher understanding of the unspoken beauty of humanity. Persons with dementia embody a deeply rooted yearning for love and expect endless possibilities for its fulfillment. They receive love graciously and return it without pretense. When therapists, caregivers, family members and friends are willing to parallel the unconditional acceptance, emotional giving and authenticity that they are offered by persons with dementia, there is true meeting at the crossroads of love.

SEGMENTS OF THE DANCE/MOVEMENT THERAPY PROCESS

We have discussed the ways in which dance/movement therapy relates to the needs of the person with dementia. In practice, sessions can be outlined into seven distinct segments, each with a purpose specific to meeting the needs of the participants. These are:

Preparation of the space

Invitation

Opening/greeting

Warm-up

Exploration of themes

Processing

Closure

Each of the above segments includes purposes and techniques specific to meeting the needs of the participants. These are described in further detail below. Prior to these descriptions, some information on the preparations of the therapist, also an essential element, will be discussed.

Preparation of the therapist

Preparation begins with slowing down and opening the psychic space of the therapist. Techniques such as clearing a space (Caring Touch), stretching, grounding, stepping outside, leaning on a tree or laying on the ground (Grossman 1998) enable the therapist to become open to the needs we have described and the creative work about to take place in those

with whom she moves. After this preparation, the next step is to prepare the therapeutic space. Attention to the 'container' or the safe, sacred physical and psychic space is important for both the group members and the therapist. The preparation varies with intensity, depending on the persons in the group and each one's ability to help create the 'holding' space.

Preparation of the space

After preparation of the therapist, preparation of the space begins. This preparation goes beyond the physical setup of the room. Intention must be brought to the space by the therapist. Depth of experience and the ability to meet the needs of each person is affected by the therapist's ability to create what Carl Jung called the 'Temenos' or sacred vessel. We call this 'the healing place' (Thompson 1991). Dance/movement therapists explore the interplay between movement and space, enabling soul work to take place through the body for healing. In-depth attention given to space allows reverence for body and soul to develop. Persons with dementia may have lost memories and images of how to make a safe space and hold a place for themselves physically, psychologically and spiritually. Therefore, it is the role of the dance/movement therapist to help access the strengths of the person to aid in his or her own healing process. The therapist uses his or her own kinesthetic and intuitive sense, by moving into, through and around the space, to assess if the space feels right to welcome participants. A space is made within which all can feel included.

Effectively preparing the space can include prayer and cleansing rituals akin to ancient religious traditions. The process can also include the assistance of one or more co-therapists. As a co-therapist, music may be considered in the preparation of the space, intensifying the safety within the space. It can also act as a transition from ordinary time to the extraordi-

nary or sacred time of the therapy session. Furthermore, after a number of sessions, a kinesthetic inclusion may be noted by those who often remain on the outside of the group, as they gradually become part of the circle and then even enter the center safely. Hence, their new and closer physical proximity to other group members may reflect increased comfort and feelings of belonging to the group.

Physically, the space must be made safe for movement. As persons with dementia often have a compromised sense of space and time, it is necessary to establish, for each member of the group, a structure to provide a focal point for spatial orientation. For instance, too much open space may be as frightening as too cluttered a space. A balance is needed. Therefore, giving attention to the physical space available for movement is very important. Consideration should be given to the possible range of movement of those involved. For example:

> Wider, more open space should be provided for those with more focused mobility and range of movement, while more enclosed spaces seem better for those who wander, or whose kinesphere (personal bubble or reach space) and movement vocabulary is small, narrow or limited. The structure of the environment helps to answer the question of 'Where do I go?' often voiced by persons with dementia. It assures that each is included, has a place and is valued.

> Preparing the room establishes a boundary of safety. Safety is enhanced by eliminating anything that may be dangerous such as sharp-edged furniture, slippery floors, etc. Group members may assist in preparing the space by rearranging chairs, transitional objects, curtains, pillows and other objects in the space.

When a space is set and uncluttered, internal and external feelings of chaos can be dissipated. Stimuli that overwhelm a person with dementia are softened and lowered in an effort to decrease fear and anxiety. Walking paths and a circle of chairs are key factors in establishing what can be considered a safe and sacred space for healing movement.

D. W. Winnicott speaks of the necessity of a 'Good Enough Mothering Space' needed both in early childhood and for one in the midst of a dementing illness in order to relieve the 'primitive catastrophic anxiety about falling…forever or to pieces' (Sandel and Johnson 1987). It is the role of the dance/movement therapist to make and hold, through spiritual, emotional and bodily interventions, the 'good enough holding space' (Chodorow 1978). Making the safe space is paramount in meeting the needs of comfort, inclusion, attachment, and love for persons with dementia.

Invitation

Meeting the need for inclusion begins with an invitation. The invitation consists of the recognition of each person and how we might best enter that person's space. Attention must be given to the manner of approach. The therapist should slow down and explore if it feels right to stand next to a person, or how close or far away she should be. An open extended hand might be all one person needs, while another needs to 'hold on' and walk with the therapist. Some persons move better by literally dancing to the session. Invitation to the dance is not just one to one, it immediately becomes a group experience. No one wants to be the first person alone to enter the 'Dance Space', no matter how well prepared. Beginning interactions

with a number of individuals, it is possible to engage in a 'pied piper' manner of gathering.

Once in the space, we have found that someone needs to hold the space from the start. If the therapist leaves, it soon follows that the participants move away from the space. It is here that music may function well as co-therapist. 'Holding music' may be played as a way to reduce anxiety among group members. Moving, or the thought of doing so, may not be pleasant to some. It can in fact be very frightening. So in greeting and inviting persons to the session we might say, 'I'll walk with you if you'd like' or 'May I stand with you?' A dignified choice is always given, and it is often stated that, 'You are welcome anytime'. Negotiation and collaboration are employed. The words 'I will walk (or dance) with you' may engender a sense of trust and a positive response to attend the group. When two or three persons move together with the therapist it often sparks the interest of others, drawing them into the process of dance/movement therapy.

Opening/greeting

As persons enter the space, some want to sit (just the walk to the room was the dance!), some move only with the therapist, some move with each other and some say 'I'll just watch'. Watching, or witnessing, is an integral part of the process (Whitehouse 1979). It is a collaboration in holding the space for each other. Even though one may choose not to move, one certainly may be 'moved' by watching others express and release.

There are many ways of meeting and greeting one another in the dance space. Saying names, blowing kisses and waving hands or feet may serve this purpose. In addition, an introductory welcome can be given to all by the therapist 'Welcome to emotion in motion. What would it be like to show in your face

(or hands, or body) how you feel right now?' Whether subtle or exaggerated, the movements of each person express 'where' he or she is at that moment.

The period of greeting serves to acknowledge and help persons to be aware of the formation of the circle and the individuals in it. The greeting begins a time of heightened bodily awareness as the senses are engaged. Finally, this time allows the group to begin making physical connections that will ultimately lead to deeper psychic and spiritual connections as the session progresses.

Warm-up

Inherent in each dance/movement therapy session is the 'warm-up' of the body. The mentioning of body parts led by the therapist begins a process of bodily awareness. The uniqueness of each person is reflected in body type and structure as well as expressive movement. The way the body holds itself and moves reflects the inner soul of each. In the older person with dementia the hips are often 'frozen' with decreased sensation and mobility for a number of reasons including fear of falling as well as life issues, particularly those sexual in nature. It is important to note that often in this population the ability to ambulate may be compromised due to a number of physical factors. The hips and torso become more rigid and fragile and are often susceptible to stress fractures. Attention is given to body boundaries and issues of shame and/or embarrassment that might surface by assuring all gathered that 'there is nothing you *have* to do. What might it be like to try something?' It is here in the warm-up that elements of play, timalation, touch and celebration may surface. Attention to the sense of what it is like first to find a body part and then explore what it is like to move it often elicits emotions. Reminiscence often begins as, for example, someone bends an elbow, saying,

'I need some elbow room' or 'Hey, put some elbow grease into it'. Invitations to touch elbow to elbow may bring laughter and interaction.

Once sacred internal and external holding spaces are established, the invitation made, the group formed and movement begun, healing may be awakened and supported. In the practice of dance/movement therapy, the fulfillment of people's core needs also aids in the transpersonal and universal collective quest for wholeness. In explaining his formulation of these needs, Kitwood contends that, 'the concept that I shall use here is a strong one, meaning "that without the meeting of which a human being cannot function, even minimally as a person"' (1997, p.81). As dance/movement psychotherapists, we believe that the fulfillment of such needs leads into the larger arena of the holistic healing process.

Exploration of themes

As movement continues beyond the warm-up, exploration of themes presented in the body begins. This time allows for the feelings of the spirit to be expressed fully and can enable persons with dementia to 'move' from where they are to where each one needs, wants or is able to go. Time for exploration can encourage and challenge group members to move to the fullest extent possible for the purpose of promoting health and healing. As themes are explored, the needs of inclusion, attachment, comfort, occupation and love are brought to light and addressed.

Perhaps it is the heaviness of disease, loss and grief that pulls Mrs. C downward to the horizontal plane. Perhaps it is the isolation that drives her body to shrink and enclose, eventually laying silent in what appears to be a

> frozen, paralyzed fetal position. As the dance therapist mirrors Mrs. C, she too lays in the horizontal plane, and embodies that limpness often associated with depression, illness and fatigue. In their shared silence awareness, recognition and movement emerge. In their shared movement dialogue empathy, comfort and connection prevail. Perhaps it is the sense of being seen, met and responded to which brightens Mrs. C's affect. Perhaps it is the relationship with another which aids in her ascent to the vertical plane.

The horizontal plane is one of listening, exploring and communication. Clinically, when 'stuck' in this plane, one may literally 'collapse out of the vertical as if pulled downward toward the horizontal'. (Lewis 1996, p.14). The classic S-shaped curve shown in Figure 2.1 may be detected. Furthermore, 'this posture gives the impression that individuals "can't" do what needs to be done in order to be proactive and move forward in life' (p.14). Faced with the progression of dementia, it is not surprising that Mrs. C may indeed feel an inability to move forth in her life.

Processing

Inherent in dance/movement therapy is a time for processing the work that has been carried out. Verbal in nature, this is a time intended to allow what has happened in the session to shift and to settle. During this time, group members receive feedback from peers and the therapist, often resulting in integration of the exploration taking place earlier in the session.

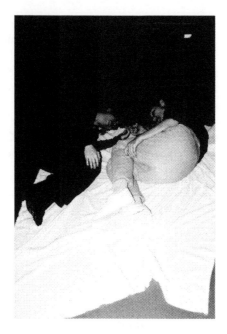

Figure 2.1.

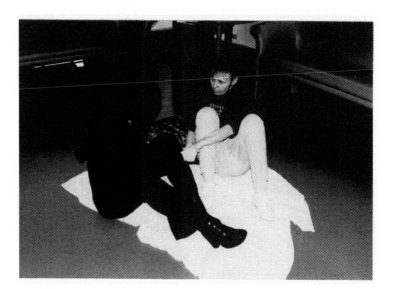

Figure 2.2.

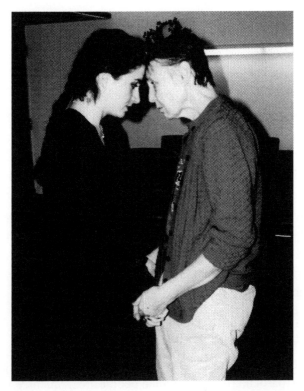

Figure 2.3.

Closure

After the work of the dance/movement therapy session, time and space for closure of the experience is provided. In much the same way that preparation of the space is more than just a time for setting up the room, closure is much more than a time for 'wrapping up' and leaving it. The purpose of this time is to prepare for the transition from intense and extraordinary session time mentioned before, to the ordinary, routine time of daily life. It is a time to put into safe places the sensitive emotions and feelings released or uncovered during the session. It is also a time to assure each person that he or she can

take with them any feelings or parts of the experience they choose. Both peers and therapist give this permission.

SUMMARY

Our journey into the experience of dementia through dance/movement therapy can help caregivers and therapists reflect on their own lives. Dancing and moving with others can open hearts not only to the fears and frustrations of life, but also to the magnificent strength and beauty manifested in bodily expression and communal bonding. Those persons with dementia have a gift of hope to share with us. Through their simplicity, vulnerability and deep wisdom, they lead us in an everlasting dance where as partners, we may share the universal choreography of life.

SUGGESTIONS FOR CAREGIVERS

Movement activities can be wonderful additions to any care setting, particularly one in which people are frequently 'on the move'. Any number of movement activities can be carried out by staff and family caregivers. People continue to move throughout their lives. Arms, legs, hands and feet are the most obvious parts in motion but we also need to remember that breath itself is a form of movement, and can be drawn upon as a starting point for successful movement experiences.

Even as we mention that people continue to move throughout their lives, we must also mention that some forms of movement may become more difficult or limited as a person advances in age and/or cognitive impairment. This can be related to both physical and emotional issues. Often, persons with dementia have lost some confidence in moving freely. This can be due to an inability to accurately perceive their physical surroundings, but can also stem from a fear of being

unsuccessful or embarrassed by their own actions. While there is no one way to assist people in overcoming these barriers, at least temporarily, the best suggestion we can give is to go gently, attempting to figure out what might be causing the difficulty, and going from there.

Including movement into your setting can have many benefits. Most obviously, increasing the physical movements of persons who have become less mobile can help to increase the flow of blood and oxygen throughout the body. Movement can also be a source of wonderful social interaction and a means of promoting discussion and reminiscence.

A simple suggestion for incorporating movement into the environment is to encourage participants to share their memories of dancing from various times in their lives. This can be accompanied by appropriate music that encourages participants to actually experience the dances again. It is important for caregivers encouraging this to be aware first of any physical precautions that might need to be taken to ensure safety. This can include clearing objects in the dancing space and providing support for persons who may be physically unstable. In addition, it is important to recognize that people can become very active and animated when engaging in such an activity, and may not realize their own fatigue before it overwhelms them. As such, caregivers must be on the lookout for signs of over-exertion, suggesting breaks in the movement as needed. These breaks can be a wonderful time to continue the activity through reminiscence and praise for each individual's contribution to the group.

When exploring actual dances, it can be especially helpful to explore the cultural similarities and differences between members of your group. Doing so will give you a starting point for choosing music to encourage movement.

In addition to traditional dancing, it can be effective for caregivers to simply 'pick up' and reflect the movements of individual participants in the group. For example, rather than suggesting the group raise their arms, suggest, 'I see Mary is tapping her toes to the music. Let's all try it.' Demonstrating and reinforcing what one participant is doing serves to offer reassurance that he or she is a contributing member of the group. In addition, it can help to encourage awareness of others within the group. A further variation on this reflection is to encourage the group to explore making the movement bigger or smaller, louder or quieter, faster or slower, etc. This can help participants to explore their abilities to move successfully, without specific expectations.

Chapter 3

Principles of Person-Centered Care in Music Therapy

Karen Hatfield and Natalie McClune

Mrs. M walks around and around the unit at a moderate pace, clutching a stuffed bear. The look on her face is worried, the look in her eyes distressed. Her posture is stooped and her body tense. Even as she walks through the unit, she appears to retreat into herself. At this moment in time it is impossible for Mrs. M to accept any interaction, even that of a well-meaning caregiver walking quietly alongside her, patiently trying to provide whatever support she might need. Across the unit, sitting with a small group of residents, the music therapist begins singing 'You Are My Sunshine'. Shortly after this begins, Mrs. M alters her circular course and walks deliberately toward the therapist, who, noticing this change in action, repeats the song several times to allow Mrs. M to complete her journey. Still clutching her bear, Mrs. M reaches her destination. Standing beside the therapist, she joins quietly in the singing, becoming

more animated and swaying slightly to the music. As this continues, the worry fades from Mrs. M's face, she stands taller and her grasp on the bear transforms from clutching desperately to holding, as if a baby. As these changes take place, Mrs. M communicates with the therapist by looking directly in her eyes and smiling as she sings. As the last repetition of the song is completed, Mrs. M looks at the therapist and says clearly, 'Thank you. I'll take that with me.' With that, Mrs. M resumes her journey around the unit, shoulders back, face relaxed, and spirit lifted, her ability to take part in the world around her renewed.

It is often said that music itself and the techniques specific to the field of music therapy have the power to reach persons with dementia. What, however, does this really mean? Through research we have come to understand that persons with dementia can continue to have positive cognitive, behavioral, physical and social responses to music long through the progression of dementia, (Fitzgerald-Cloutier 1993; Lipe 1995; Pollack and Namazi 1992). Beyond our ability to elicit and observe such responses, however, how might we know when we have truly reached someone through our music and our presence? How do we recognize when we ourselves have been reached? Perhaps it is when the music and the setting combine to allow us to express our most heartfelt joys, sorrows and frustrations. Or perhaps when some combination of words, rhythm or melody conveys to us that while what we are experiencing is unique, it is in that same instant universal. We believe that life is much the same. Each of us has our own experience and understanding of the world. At the same time, we find it possible to relate to others in it because there are times when our experiences and understanding may be similar. The experience of music, as that of life, can be unique to each person, while at the

same time containing features similar enough to prompt most of us to understand the depth to which others may be affected.

Music therapists who have experienced, facilitated or witnessed the deep connections possible through music know that the qualities of these experiences move beyond descriptions such as 'Mary remained seated and on-task for twenty minutes of a thirty-minute session, exhibiting decreasing signs of agitation throughout that time'. Therapists all over the world have often left sessions marveling at the wonderful tranquility or joy they witnessed in the individuals participating in those sessions. From the therapist's standpoint, we would argue that the excitement felt after an 'effective' session has as much to do with the quality of the client's experience as the ability to objectively describe his or her behaviors.

We often justify the need for music therapy by describing it in terms of being a cost-effective treatment option or by attempting to prove that it can restore a person's behavior to socially acceptable levels. While these issues have proven to be important in the development of our profession, relying on them as our primary frame of reference with regard to dementia reduces the art of music therapy to a set of isolated behaviors to be changed and manipulated. As therapists, it is important that we attempt to understand what the experience of music therapy might mean for the person receiving it. The 'touching of the heart' or 'striking of a chord' within each individual cannot be easily documented through traditional means, and we are often at a loss to describe these phenomena. Nonetheless, we know that it is significant and powerful when we find a way to create these experiences with and for persons with dementia.

Though it is necessary to use terms describing individuals' behavior or actions during music therapy in order to know *what* happens, we also believe there is a need to look beyond what is easily seen to what might be felt by the person with

dementia as he or she shares in experiences with the therapist. In the case of Mrs. M, for example, we are easily able to see many of her responses to the music provided by the therapist. Her pacing halted for a few moments, her grasp on the stuffed bear softened, she made and maintained eye contact with the therapist and she sang and moved in time to the music. But what is it about the experience for Mrs. M that made these changes possible and even necessary? Perhaps it had to do with the session being held in an area that Mrs. M would naturally encounter in her travels around the unit. This might have helped her to feel safe in entering that space briefly to engage in the music. Or perhaps it was the sound of the therapist singing, combined with her positive response to Mrs. M's change in direction. This might have helped Mrs. M to feel welcomed as she approached the source of the music. We need to recognize that music therapy did more than allow Mrs. M to participate musically for a time. Music therapy allowed Mrs. M to feel included and form a bond with the therapist, even if only for a few moments. It allowed her to utilize her voice, thereby reinforcing her awareness of herself. Music therapy enabled Mrs. M to take part in a relationship with another person through music that would have been difficult, if not impossible without it.

Can we interpret other behaviors in the same manner? Is it not possible that the person whose moans gradually decrease in the presence of the music therapist does so in response to being truly heard and responded to in a way that honors the meaning behind the moaning? Can we imagine that the person who displays 'difficult behaviors' with his peers might find a role within the music therapy group, thereby helping him to find meaning in his actions and allowing others to see him in a more positive light? In general, we are asking you to be open to the possibility that behaviors might change because an emotional

need has been met. A person might stop pounding on doors once she realizes that her efforts have been recognized and she can move forward to more fulfilling communication with the person who has heard her.

As described in the introduction of this book, person-centered care purports a set of basic needs that can be attributed to all persons with dementia, and indeed to all persons without dementia as well. Additionally, we talk of supporting the personhood of those with dementia. If we assume the validity of these basic needs and accept that the theory of personhood implies '...recognition, respect and trust' (Kitwood 1997), we then have a basis for successfully developing, implementing and interpreting music therapy practices that will support these concepts.

There is little available research to describe music therapy as it relates to the theories of person-centered care developed by Tom Kitwood and the Bradford Dementia Group. As previously described, it has commonly been the way of researchers specializing in music therapy and dementia to explore those aspects of the field that can be observed and measured. Indeed, in many of our own previous investigations we have tended towards studies attempting to isolate specific outcomes of the therapeutic experience such as socialization, participation, cognitive engagement and physiological change (Fitzgerald-Cloutier 1993; Hatfield and Kasayka 1996, 1997; Kasayka and Hatfield 1995; Pollack and Namazi 1992). These and other similar investigations are extremely valuable to our understanding of the outcomes possible in music therapy.

Now, however, our journey into person-centered music therapy challenges us to look beyond what can be isolated and measured. Though research is limited, a number of writers have described the phenomenon of music therapy with persons with dementia in terms that imply the appropriateness of a

person-centered approach to practice and case reporting. In *The Lost Chord*, Chavin (1991) stresses the importance of allowing the individual to 'take the lead' with regard to the therapeutic interaction. In addition, Chavin discusses the idea that it is not the therapist's role to alter 'faulty' behavior of the client. Rather, she proposes that it is the responsibility of caregivers to alter their actions in order to meet the needs of the individual. Silber and Hes (1995) discuss the process of songwriting with persons with dementia, which may provide opportunities for the expression of deep emotion and may counteract the negative social, emotional and cognitive influences of the disease. More and more we see the focus shifting from music therapy as a behavioral intervention to music therapy as a means of comfort, growth and continued well-being for the person with dementia in an overall program of person-centered care.

An underlying principle of person-centered music therapy is that the actions of the person with dementia are messages of some type that the individual is attempting to communicate to the therapist, other caregivers, residents and/or his or her family. As in person-centered care itself, all actions are seen as meaningful (Kitwood 1997), whether or not that meaning is easily identified by those who do not have dementia. In a sense, the actions of the person with dementia can be seen as mysteries to be explored and 'solved' by the individual and therapist together. Person-centered music therapy is a means by which we can enable persons to continue experiencing personal growth in spite of advancing cognitive impairments. These experiences lead to improved well-being in the individual with dementia, which is the overall desired goal of person-centered care itself.

In reference to Kitwood's 'flower model', described in the introduction, it is possible to address each aspect of need

(comfort, attachment, inclusion, identity and occupation) identified in the petals through a number of person-centered music therapy interventions. It is understood that as one of the five needs is addressed, the influence of the intervention then also applies to one or more of the other components (Kitwood 1997). For example, when a person's cries of 'Where do I go?' are met with compassionate reassurance and a sincere invitation to attend music therapy, the areas of inclusion and attachment are simultaneously addressed as the individual joins and subsequently forms bonds with both the therapist and others attending the group. Throughout the remainder of this chapter, we will provide examples of person-centered music therapy, as well as discussions of possible ways in which these interventions might address one or more of the emotional needs set forth under the philosophy of person-centered care.

GETTING STARTED: SOME THOUGHTS ON COMMON APPROACHES

Any therapist who has attempted to gather a group of people together for a music therapy session knows that it can be challenging. It is common knowledge that it is often possible to approach a person with dementia several times to gain a desired outcome. This, of course, is not a phenomenon exclusive to music therapy. Caregivers, family members, activity professionals, nurses and physicians, as well as therapists frequently use this 'trick' to gain access to a person's cooperation, assuming that deficits in short-term memory will allow each approach to be perceived as the first by the person with dementia.

A phenomenon identified by Kitwood (1997) is 'treachery', which is the practice of telling small lies to gain the cooperation of the person or to ease his or her feelings of anxiety or agitation. We often think nothing of using these

methods, as we rationalize that what we are doing is in the individual's best interest. We assume that the people in question do not possess the capacity necessary to make many of the decisions that arise from the choices we offer them. If this is the case, why do we offer choices in the first place? Music therapists often 'know' that a person will enjoy and benefit from a session, and so have quite a clear conscience when telling these 'therapeutic fibs'. The theories of person-centered care would challenge this, however, encouraging us to understand that even mild episodes of treachery degrade the basic trust that should exist between people. As therapists, it is ironic that we would resort to such measures, as we often state that one of our first priorities includes building rapport with our clients. Imagine for a moment how you might feel if at some level you became aware that you had been falsely charmed or coerced by a trusted friend.

We must also consider the possibility that persons who are approached again and again or mildly coerced into compliance after initially offering a refusal, may actually 'perform' more poorly than they would had their wishes been respected in the first place. Results of a study conducted at our facility indicated that the cognitive engagement scores of persons who were persuaded to attend sessions after initially refusing were routinely lower, even extending to negative scores, than those of the same individuals when they agreed to attend without multiple invitations. We determined that the total scores of these individuals over twelve weeks would have been higher if we had simply included the score of 'zero' attributed to refusals, rather than having to enter the negative scores that sometimes resulted from a person attending after a series of revised invitations by various staff. From both practical and personal perspectives, this indicates that we should refrain from assuming

that we always know what is best for a person, simply because he or she has dementia.

In our exploration of person-centered music therapy we have faced the challenge of boldly telling the client the 'whole truth' of what the music therapy session will be about. You may guess that such explanations have led to many refusals to participate, some based on the inability to understand the complexity of the information given, while some are based on an aversion to the word 'therapy', and the distinct lack of enjoyment it implies. Some refusals have merely been grounded in a simple desire not to participate. Unfortunately, in many settings, people who make these genuine, well-founded decisions are labeled 'difficult', resulting in the subsequent use of tricks designed to gain their cooperation. Where, then, is the balance between treachery and 'too much information'? We have found that the balance lies in inviting the individual to join us for a time for music and a chance to 'see how things are going' either with the therapist alone or with a group of people the therapist feels the individual might enjoy spending time with. Other explanations we have found useful include 'Jane, you and I spent time together playing some instruments yesterday. It seemed to help you feel better. Will you try it with me again now?' This direct approach incorporates sentences that are short and concrete, increasing the probability that the person will be able to understand the information. In addition, the approach respects the individual's right to receive information regarding the experience being planned, while providing that information in a manner that is manageable.

At a very basic level, the approaches described above address a number of the key concepts of person-centered care. The most obvious is the assumption of recognition, trust and respect, referred to earlier. The individual is recognized by name, accurate information is provided in order to gain or

maintain the person's trust, and ultimately the therapist respects whatever decision is made by the individual. We can also see the needs for inclusion, attachment and identity being addressed in the process of inviting. In response to a sincere offer of company through music, the person with dementia feels a part of something larger than him or herself, fostering a sense of inclusion. We can never over-estimate the value of feeling that others desire your company. The mutuality of the exchange between therapist and person with dementia allows for the experience of attachment to begin. Finally, the recognition of the person for his or her unique contribution to the experience helps to reinforce identity, regardless of the person's ability to independently recall the events and contributions brought forth by the therapist.

CREATING THE SPACE

Creating the space in which the session will take place is a matter worthy of some consideration. For group work, we commonly use a circle that has one opening for people to use if they feel the need to leave the session. While it is a goal to have the participants engage in the experience at some level for the entire group, we understand that for our approach to be truly person-centered, we must allow each individual to make his or her own decision to stay or leave the group. While this may sound like it could create chaos in the group, we have found one of three things to be generally true.

The first is that people with dementia occasionally stand up before the completion of the group because they have been cued by someone else's movement or they have an impulse that makes them feel vaguely like they need to be acting rather than sitting. In this case, the therapist will gently ask, 'John, are you leaving us?' In many cases, John will look unsure, and may or may not verbally answer the therapist. A following question

might be 'John, would you like to stay with us?' If the response is in the affirmative, the therapist might then show or tell John where he can sit, helping him to feel comfortable in any way necessary.

The second possible explanation, and the first one to rationalize the opening in the circle, is that the individual wants to remain with the group, but is unable to tolerate sitting for any longer. We must stop identifying this as 'difficult' or non-compliant behavior. If a person needs to stand, or walk around the room during a group in order to continue a comfortable level of participation, then so be it. The therapist can respond to the individual as in the first example, asking if he or she would like to stay. If the answer is yes, but it is evident that sitting down again is not the answer, the space allows for easy movement out of the immediate circle without additional commotion caused by asking people to move.

The third potential 'truth' is that all things being equal, people sometimes leave the group because they have had enough of whatever the experience is. This is not to say that the music therapy group may not have been beneficial or meaningful to the person in question, simply that variations in attention, interest and need are to be expected in any situation. We must learn to trust that people can continue to make decisions based on what they need at the time.

At times, it is also possible that you will be unable or will not want to ask people to move from the common spaces of a unit to a separate room for music therapy to take place. Obviously, this can have to do with space limitations; however, we are more concerned here with intentional decisions to provide music therapy sessions in common spaces. These decisions may have to do with providing maximum comfort for an individual, or structuring an open group experience that will provide the opportunity for inclusion of persons either unable or unwilling

to accompany the therapist to the closed space. This is sometimes the case with individuals who feel the need for constant movement, as with Mrs. M in our opening example. Structuring a group in the common area allowed Mrs. M to attend and participate as she was comfortable, rather than forcing her to conform to our ideal of a private, distraction-free room. For others, the experience of moving from the common area to a closed space, while not inherently negative, demands more energy than they have available, leaving them unable to benefit from interaction with the therapist when the session finally begins. For this reason, we do intentionally facilitate some sessions in common areas. It is then the therapist's responsibility to help other staff and visitors to understand and support the process taking place, encouraging them to assist in 'holding the space' for the residents, as well as participating appropriately if they wish.

We are fully aware that these shifts in thinking and approach can initially make some aspects of therapy more challenging. We believe however that doing so will eventually lead to greater depth in your sessions, as well as greater satisfaction in the interactions you are able to have with persons in any phase of their dementia. Furthermore, the example you are able to set for the remainder of the care staff can help to improve their overall understanding of the potential to develop meaningful relationships with the persons living in or visiting the care facility.

SESSION TYPE AND THERAPEUTIC INTERVENTION

Both individual and group interventions are useful in addressing issues of personhood in music therapy for persons with dementia. The decision to engage in one over the other is dependent upon the needs of each specific participant. In general, participants in significant emotional or physical

distress are more effectively served by music therapy provided individually. This experience allows the therapist to offer support and assistance that is most-tailored to the individual and his or her needs, thereby increasing the likelihood of the person returning to a state of well-being. It is not uncommon to see one of us walking with an individual for extended periods of time, alternating singing and rhythmic improvisation with periods of talking and silence until that time when the transformation from distress to a more peaceful state of being is made. It is easy to see the fulfillment of attachment and inclusion needs in these cases. Identity, while perhaps less obvious, is addressed as the therapist devotes a great deal of energy to providing immediate verbal and nonverbal responses to the actions of the individual. By providing this feedback throughout the interaction, the therapist is able to help the person maintain his or her role in the relationship, along with the awareness of his or her own uniqueness.

Group sessions are often extremely useful in creating a structure in which support can be given and received between participants as well as between participants and therapist. Issues of inclusion and attachment are addressed particularly well as participants are able to recognize that they are not alone, and that the people around them have similar struggles and triumphs. Though expressed in many ways, a great number of people have verbalized thoughts such as, 'At least we're not alone', or 'Oh! I have that problem, too!' The friendships that have arisen from participation together through music therapy are a testament to the importance of well-facilitated, ongoing groups, as well as the inherent strength waiting to be rekindled within many persons with dementia.

Even as we attempt to determine schedules for the therapists in our program, we are aware of the need for unstructured time in which each of us can seek out those participants who

could benefit from additional support and/or intervention through music. As in the example of individual music therapy above, these interventions often address the acute feelings of ill-being that people with dementia may experience when their emotional needs are not being met. It is imperative to remember that no matter what terminology we use to describe this condition of ill-being, whether distress or agitation, unresponsiveness or withdrawal, wandering or pacing, there is a reason that people engage in the actions (or inaction, in some cases) we see. A basic premise of our care is that all behaviors serve as attempts for communication. Therefore, our goal as person-centered therapists is never simply to change the behavior of an individual, but rather to provide a supportive space in which each person can carry his or her communication through to its conclusion. This is particularly important with regard to persons in acute distress with whom we work individually.

INTERVENTIONS IN PERSON-CENTERED MUSIC THERAPY

Drumming

Drumming, as a therapeutic intervention, has been studied by a number of researchers over the past years (Clair and Bernstein 1990a, 1990b; Hatfield and Kasayka 1997). In our 1997 study at Heather Hill, we found that for persons with mild to moderate cognitive impairments related to Alzheimer's disease, group improvisation around a table drum resulted in high levels of group cohesion, social interaction, and entrainment.

In the study, participants engaged in a group drumming protocol, using either a table drum or hand drums shared with a partner. Upon invitation to each session, participants were asked to attend a music group in which they would help us determine the best way to use the table drum. After being

seated, the therapist introduced herself and reiterated the purpose of the group. After that, she greeted each of the group members by name and asked each to 'give a tap on the drum to say hello'. With that, each member played for as long or short a time as he or she chose. In many cases, other group members would begin playing along with each other, reflecting the rhythm and intensity of each individual's playing. After completing this round of playing, the therapist asked the participants if they would like to improvise as a group. Upon agreement of all group members, the therapist explained that one person would begin a steady beat, and that the others should join in playing as they wished. Generally, the therapist invited one of the group members to begin the improvisation by beating steadily on the surface of the drum. When a pulse was established, the therapist began playing steadily along with the person who began. Verbal and/or visual cues were provided to other members of the group to encourage their participation in the improvisation.

Over the course of the study, we found that communication increased between group members both in and out of the drumming sessions. Attachments were formed and supported by the drumming intervention as well as the presence of the therapist and group members. People who entered the room after it was prepared for the session indicated a sense of belonging and excitement that they had 'found the right place'. The support provided by and for everyone in the group (ourselves included) more than adequately met each person's need for love and inclusion, as every individual was accepted unconditionally for whatever he or she was able to contribute musically or non-musically. As each person contributed individually and was then recognized for qualities unique to his or her playing style, identity was addressed and reinforced. Finally, as group improvisation continued over the twelve

weeks, episodes of rhythmic entrainment (matching an existing rhythmic pulse) between group members became more frequent. The deep social, emotional and physical engagement indicated by this phenomenon suggests a level of completeness that would indicate the potential for this type of experience to address each of the needs of persons with dementia simultaneously.

Individual drumming sessions can also be beneficial in maintaining personhood and encouraging expression in persons with dementia. One example in particular illustrates the emotional benefits associated with this intervention. Mr. R, to whom reference has been made in Chapter One of this book, was a gentleman with advanced dementia. He rarely spoke, and needed a great deal of assistance in his activities of daily living. He was able to eat independently, but normally chose to pound out rhythms on the dining table with his utensils rather than engage in consuming the food in front of him. Mr. R's life prior to retirement included work as both a minister and college professor. During his time with us he maintained a rather stoic countenance at most times, though his eyes belied a deeply kind and sometimes mischievous nature. We became involved with Mr. R as a result of his rhythmic expression on the dining table. We felt that Mr. R might derive more pleasure and benefit from these rhythmic improvisations if someone responded to him in kind. Generally, the music therapist would invite Mr. R to join her in a closed family room on the unit. At times, the therapist and Mr. R shared a large hand drum placed between them, resting on their knees. Mr. R was most comfortable using a mallet, and so was provided with one for the drumming sessions. On most occasions, there was no need for the therapist to initiate the drumming. Normally, as soon as both parties were seated, with the drum placed between them, Mr. R would begin playing enthusiastically, maintaining eye contact with

the therapist throughout the improvisation. It was not unusual for Mr. R to continue the musical interaction between himself and the therapist for up to ten minutes at a time, breaking for only seconds to cue the therapist to respond to his rhythmic 'questions'.

On one occasion soon after the drumming began, Mr. R picked up the drum and held it in his hand. For the next five minutes Mr. R played steadily with tremendous energy and volume. Abruptly, he stopped, placed the drum in the therapist's lap and handed her the mallet. After several moments of silence, the therapist asked very gently, 'What was that?' In response, Mr. R said, 'It was me. It was all me'. After several simple comments on the energy and power she noticed in Mr. R's drumming, the therapist asked Mr. R if there was anything else he wished to do in the session. He replied simply by saying, 'Done'. The session was over.

This example illustrates the completeness of the musical experience for certain persons with dementia. Mr. R was able to fully express himself through a period of drumming in which the therapist devoted total attention to simply hearing and being with him. And while the sound produced by Mr. R's beating of the drum was actually quite overwhelming, no attempt was made to structure or limit his expression. It was important for Mr. R to have time to freely express all the energy, power and complexity often overlooked by those who did not understand that his pounding on the tables was really his means of sharing himself with the world as he became less able to do it in other ways.

Preserved music skills

It is with surprising frequency that we meet people in our facility for whom performing music has been a significant part of life. The support and interventions needed are unique for

these musicians (as, of course, they are for all persons), as the method of intervention is also the area of accomplishment. In working with these individuals, issues of identity and occupation are of utmost relevance. These are highly significant because persons who have been extremely active in music may often define themselves by it, and the loss of the ability and/or opportunity to successfully engage in active musical experiences can result in feelings of 'lost' identity.

When working with people who have been musically active, it is important for the therapist to determine what the overall reason for therapy is. While we will of course meet each person as he or she is in any given moment, it is possible to draw some conclusions regarding the reason for the intervention in the first place. Is our purpose to encourage the use of the skill in order to maintain active participation in a meaningful activity? Or is it to help the person to reconcile the emotional consequences related to his or her possibly diminishing performance skills? The reason may be one or the other, or it may be a combination of both. And this may change from day to day, as the needs of the person with dementia change.

In this work we must first consider when and if structuring opportunities for the person to utilize his or her musical skills will actually be beneficial. Very often we assume that because a person has been an active musician, he or she will still want to play. At times, however, the skills that have been the source of so much pride have diminished so significantly that continuing active music making can lead to high levels of distress. In these cases, the first priority of the therapist is to validate the person's possible feelings of loss, grief, sadness and anger at his or her inability to maintain the standards previously achieved. This can be accomplished through discussion of the skill and the feelings related to the work it took to accomplish the level of competence once enjoyed. It may be possible to help the

person to regain some level of pleasure in utilizing his or her musical skills, but the process must include acknowledging that the changes in skill have resulted in emotions that can be difficult for the person with dementia to cope with independently. All too often, well-meaning caregivers encourage and sometimes even demand that persons with musical skills who also have dementia perform for their peers without fully understanding the emotional consequences that can occur. Unfortunately, the performance of music is indeed a *performance*, and when an individual's skills are diminishing, being pressured into playing for other people can be a potentially negative experience.

Mrs. C was a woman who had spent her life playing the piano professionally. Her résumé included formal study at a well-known conservatory of music and a variety of significant teaching and performing jobs. One interesting 'gig' she took great pleasure in telling about was the time she spent playing for the silent movies. Mrs. C was a highly trained and highly motivated musician. As she began her journey through Alzheimer's disease, Mrs. C's ability to express herself verbally diminished, as did her ability to carry out functional tasks such as eating independently and successfully maneuvering her way around the care setting. Her musical skills remained intact, however, and for a very long time, Mrs. C utilized her role as performer as the basis for interactions with the staff and other residents of the facility. In her case, the encouragement of the staff was welcomed and she was able to continue successfully. She could play from piano scores, but was also able to retrieve and perform a great deal of material from her memory. As her dementia progressed however, it became more difficult for her to participate independently in experiences that she found meaningful. Previously a very lively and outgoing performer, Mrs. C displayed progressively less and less motivation and

resilience in response to stressful situations over time. For the longest time, Mrs. C had utilized the piano as a means of expressing the performance aspects of her identity. As her confidence and ability to do this diminished, Mrs. C was at a loss as far as how to interact with others in the facility. For a time, prior to our work with her, the staff continued to encourage her to play for her peers, however as her skills diminished, their sometimes overwhelming encouragement was met with fright and anger. She was no longer able to perform up to her standards and she found it impossible to cope with the demands placed on her by the people who could not understand the level of distress she experienced each time she was put on the spot.

When we began working with Mrs. C, she was so fearful of being asked to perform that even talking about her talents caused her to become upset. We began by simply talking with her about the issues, validating her feelings of loss and fear. Soon, Mrs. C was able to listen to the therapist play, offering suggestions for improvement along the way. Her role as teacher was restored and she was able to find meaning in this activity. Occasionally we broached the subject of Mrs. C taking a more active role in the sessions. When she was ready, her contribution began with her showing the therapist her suggestion for improvement rather than simply telling her. Soon, Mrs. C was able to tolerate the therapist introducing printed music of varying complexity as well as auditory cues in order to determine what she could still manage. It is important to note that the process of re-introducing printed music and exploring her remaining strengths included fairly 'up front' discussions of why and how we might help Mrs. C to find ways to feel comfortable playing again.

As Mrs. C began to show signs of more severe cognitive decline, these discussions and the way she had been included in

the goal-setting all along proved to be extremely valuable. Even as she was unable to remember the specifics of the process, she appeared to recall the emotional safety of the situation with the therapist, enabling her to continue utilizing the skills that had so clearly defined her life. At times, Mrs. C was able to play for other residents, and the staff were provided with numerous guidelines for focusing their energy on making sure the experience was successful for Mrs. C. The shift was made from 'using' Mrs. C to entertain the other residents to structuring short periods of time that her identity could shine through and she could feel safely included in the community.

The use of preserved music skills can be very rewarding to individuals with dementia, families, therapists and other staff members. This is provided that the process of determining the course of therapy and guidelines for staff and family encouragement of the individual are made in cooperation with the person with dementia. When this happens, skills can be utilized successfully for far longer, and the experience of playing or singing will continue to be one that truly expresses the uniqueness of each individual.

New experiences through person-centered music therapy

It can be important to use musical material that is familiar to persons with dementia. Research has indicated that songs from young adulthood can elicit positive responses and stimulate memory skills (Prickett and Moore 1991). There are times, however, that the success of the therapeutic process is not dependent on the familiarity of the session content. We also believe that persons with dementia can and do enjoy and benefit from experiences that provide opportunities for expansion and change. This supports the belief that dementia does not relegate individuals to a status of mere existence. On the

contrary, we have found that the presentation of new material of an appropriate nature in a safe and supportive environment can provide equal if not greater opportunities for individuals with dementia to express their likes and dislikes, along with their fears and their sense of triumph. The experience of playing something new, for example, may allow a person to make mistakes that he or she might otherwise find unacceptable because 'I should know how to do that'. In addition, discussions regarding trying new things, making mistakes, getting older, and slowing down may be more easily broached using new music or instruments as transitional objects. The example of group drumming, described above, is just one illustration. Other experiences may include songwriting, improvisation with melodic percussion instruments and the introduction of instruments to be played by the therapist and 'tried out' by the persons with dementia. People are sometimes better able to share their thoughts, opinions, skills and emotions outside the confines of experiences that they know to have a 'right' and a 'wrong'.

It is important to introduce new experiences in a setting free from judgement and possible humiliation. It is a good idea to introduce unfamiliar experiences in small groups where the therapist can easily notice and respond to the various reactions of participants, both as they actively participate and as they watch others do so. This also increases the likelihood of group members remaining engaged with each other and the musical experience. In addition, novel material introduced to persons with dementia within the music therapy session should be limited to one or two elements and interspersed with material (whether musical or nonmusical) that promotes stability and feelings of safety. This could include familiar music, such as songs, in addition to interpersonal interactions that support such feelings.

As with any intervention, the therapist must be clear about the purpose of introducing unfamiliar musical materials and experiences to the person with dementia in the music therapy setting. For example, introducing hand drums to be shared between two or three people for the purpose of increasing each individual's sense of inclusion and attachment is likely to be more useful than introducing drums for each person in a group of twelve to 'increase participation'.

The concept of allowing the content of a session to unfold in response to the needs of the person with dementia is key to the development of person-centered music therapy. Thus, musical material that is outside the realm of 'songs from the old days' can be extremely valuable when utilized appropriately.

INTERVENTIONS SPECIFIC TO PERSONS WITH DEMENTIA AT THE END OF LIFE

Working with persons with very advanced dementia presents a set of circumstances that is always unique and sometimes challenging, particularly to those therapists who have learned to equate success with the presence of active responses. As a field, we know that applications involving rhythmic experiences continue to provide opportunities for active participation in persons with severe cognitive impairments (Clair and Bernstein 1990a, 1990b), and that other individual and group interventions can have seemingly positive effects on 'wandering' (as it is described in much of the music therapy literature) and agitation (Brotons and Pickett-Cooper 1996; Groene 1993). Where the application of music therapy is to persons who are severely regressed and perhaps rarely responsive, the research is quite limited. In a case study most closely related to a person-centered approach, Lipe (1991) describes a music therapy process with an individual with severe cognitive impairments, noting that traditional methods of research limit

the possibility of investigating 'the day-to-day existence of individuals…' Further, she suggests the need for treatment applications that provide psychological comfort, as well as research measures that allow investigators to 'infer meaning from observed response patterns'. Many components of Lipe's study and her suggestions for developments needed to adequately meet the needs of persons with late-stage dementia are consistent with the person-centered approaches and interpretations introduced in this book.

In a study at Heather Hill funded by the Kulas Foundation, it was determined that physiological arousal increased in persons with late-stage dementia *after* the presentation of both sedative and palliative music (Kasayka and Hatfield 1995). This is consistent with Pollack and Namazi's (1992) findings of increased alertness and social interaction in persons in the earlier stages of Alzheimer's disease after music therapy sessions. Taylor (1997) suggests that these changes may be a result of musically produced cortical arousal that can create situations in which cognition is enhanced.

In light of these findings and suggestions, as well as an underlying belief that it is possible to address the emotional needs of persons with severe cognitive impairments, the development of music therapy for persons with advanced dementia at Heather Hill has centered on providing musical stimulation followed by periods of time in which verbal or nonverbal communication can be explored. Both the musical interventions and the periods of time following involve material that is based on knowledge of each individual's preferences and background as well as an assumption of remaining emotional needs. For example, a woman who is known to have a highly developed sense of spirituality, who has freely spoken of death throughout her life, might be invited to a space in which the therapist quietly sings repetitions of 'In the Garden', both with

and without words, for a period of time, matching the tempo of the music to the breath patterns of the woman. The music is provided in such a way that it is gentle, but strong enough for discrimination to take place. In other words, the therapist sings quietly, but with enough vocal support and direction to indicate that the sound is intended to be the focal point of the interaction. Lasting anywhere from five to ten minutes, this is followed by a period of non-musical interaction in which the therapist can respond to any overt signs of communication put forth by the woman. This segment also generally lasts anywhere from five to ten minutes, though in instances in which a great deal of communication or emotional expression takes place, the time may be extended to meet the needs of any given individual.

Returning to the woman in our example, in the absence of outward signals, the therapist may simply offer gentle verbal recognition of the importance of the song or topic in the woman's life, as well as acknowledgement of other areas known to have significance in the woman's experience. This session would end gently, with great care taken to gradually reintroduce the normal sounds of the unit in an effort to minimize potential distress caused by the transition from highly individualized attention to the more open setting of the unit. This is accomplished by allowing a period of relative quiet between therapist and client, in which the sounds of the surrounding unit can begin to enter the room. Following this, the therapist may open the door, allowing the sounds to become clearer, finally helping the individual out of the therapy space and back into the open atmosphere of the unit.

This type of intervention can be provided within individual or small group settings. A variation in the group setting is that the session is begun with the recognition of each person in the group, with a reminder that all will have opportunities to

give and receive support. In addition, the music provided spans two to three songs that have known or potential meaning to those attending the session.

Within the structure of the type of session described above, intentional touch is often utilized for the purpose of providing support and comfort for the individual. The word 'intentional' is used to indicate that while the touch provided is gentle and hopefully non-threatening, it is at the same time strong enough to be perceived as deliberate contact. This is the same principle as we used above to describe the presentation of music in the session. Touch that is too vague can be met with indications of irritation or annoyance. In other instances, touch that is too light may not be acknowledged at all, indicating that the person may have no awareness of its presence. As with anything, a balance between gentle and intentional must be explored with each individual.

Whether touch involves holding an individual's hand, providing shoulder and neck massage or sitting with an arm around the shoulders of the individual, it is important that the therapist first ask permission to initiate this personal contact. He or she must then be alert to signals indicating permission or refusal from the individual. Signals of permission may include vocal or verbal affirmations, positive facial affect and eye contact or the sensation of the person 'relaxing into' the therapist's touch. Indications of refusal or need for time to adjust to this contact can include negative vocalizations and/or facial affect as well as an increase in the rigidity of the individual's body posture. In these cases, we recommend that the therapist spend some time attempting to determine if the signs are those of refusal or simply the need for additional time to adjust to the sensation of touch. This can be accomplished by continued verbal reassurance and asking that the individual continue to let the therapist know what is preferred. In the interest of main-

taining an environment of equality and dignity for those with severe cognitive impairments, this is an extremely important consideration. Far too often caregivers fail to inform persons who are severely regressed that they are going to be touched or moved, much less ask permission to initiate these types of contact.

In contrast to the outcome-based goals of traditional behavioral methods, the goal of this basic method is for each individual to experience musical and nonmusical interaction with the therapist in a highly individualized setting, free of overwhelming external stimuli. It has been our experience that given a setting free from distraction and in which the therapist provides music based on known preferences and possible emotional issues, the potential for communication is significantly increased in the period immediately following the music. Verbal or vocal interaction is often initiated by the person with dementia, as well as increased physical contact with the therapist. These interactions are viewed as positive responses to the intimate personal space created by the music, the therapist and the person with dementia. Additionally, they indicate the active pursuit of interactions that fulfill the need for inclusion and attachment with others. Another response to this intervention can include crying and/or other bodily releases, which we believe to be positive and valid responses to the intensely personal space shared by the therapist and the person with dementia. As mentioned in previous chapters in this book, we believe strongly that the need and ability to express a full range of emotions does not go away simply because it may be difficult for us as caregivers to understand and be comfortable with the way in which they may be expressed. In the context of a person-centered approach to music therapy, these expressions are met with acceptance and validation, and time is given for the completion of each person's communication. The fact that

it is possible for these emotions to be accessed and contained in the context of music and the other healing arts therapies provides us with a strong rationale for moving beyond the description of behaviors that can be easily isolated and explained.

RECORDED VERSUS LIVE MUSIC ACROSS THE CONTINUUM

Recorded music is sometimes used in music therapy with persons with dementia for the purpose of stimulating movement responses or for experiences related to music or performer appreciation. This is particularly true in work with persons with mild cognitive impairments. For many therapeutic purposes, however, live presentations of the elements of music are preferred as they allow the therapist to respond immediately to changes in individual and group responses. Returning again to the example of Mrs. M at the beginning of the chapter, the therapist was able to provide multiple repetitions of the first verse of 'You Are My Sunshine' in response to Mrs. M's approach and participation. Recorded music would have eliminated this opportunity, potentially causing the therapist to miss an opportunity to share in Mrs. M's world for a time. In general, person-centered music therapy interventions indicate the use of live music.

While there is some flexibility in the choice between live and recorded music for persons with milder impairments, it is our opinion that person-centered music therapy for persons with advanced dementia requires the use of live music. It is only possible to match characteristics of a person's voice, breath and movements with live music, and it is only possible to make changes that immediately reflect a person's actions when the therapist is actually producing the music. Again, reinforcing the concept that the interventions are person-centered, attend-

ing to the most current state of an individual, is an important consideration in each of our interactions.

SUMMARY

Music therapy can be an important component in an environment of person-centered care for individuals with dementia. The practices involved in this modality and the relationships possible between therapist and client can strengthen the feelings of love, attachment, identity, inclusion, occupation and comfort available to the person with dementia. If the overall environment is supportive of the emotional needs of each individual, the depth to which music therapy can address those needs becomes even greater. Prepared with information regarding personal preferences, life history and areas of concern that might be important to the person with dementia, the music therapist can structure experiences through music and supportive interactions that maintain personhood and provide opportunities for growth, regardless of cognitive impairment.

We intend for this chapter to serve as a starting point in the development of person-centered music therapy. We do not have the answers to every question and possible way in which the basic concepts might be challenged. What we do have is a precious opportunity to share in the lives of those who are finding their way along the path of dementia. As stated numerous times in the literature surrounding person-centered care, we are all simply people, together in this life. And while our therapeutic interventions must certainly take into account the neurological impairments evident in those with whom we work, to define those individuals by their impairments, robs each of us, impaired or not, of myriad possibilities for growth and healing. We challenge all who read this book to spend time looking for the ways in which the therapy you provide might

help each of your clients to maintain his or her personhood. In doing so, we think you just might also find a means of maintaining your own.

SUGGESTIONS FOR CAREGIVERS

It is possible to incorporate a great number of musical activities into any program for persons with dementia. Music is very commonly known to stimulate positive responses in persons experiencing mild to very severe levels of cognitive impairment. Indeed, it is not uncommon to hear stories of caregivers seeing significant responses to music where previously very little interaction had been thought possible.

Music can be used very successfully to stimulate meaningful interactions between caregivers and participants. Several points are worth mentioning, however, in order for you to see the most positive results from your efforts to include music.

The first thing to remember when using music is that there needs to be a balance between the presence of music and the availability of relative quiet. After a time, music used as a background becomes ineffective, and sometimes even disruptive, as individuals are no longer able to distinguish it from other sounds in the environment. One of the advantages to music is that it is a novel stimulus that works on the entire body, including the brain. Properly used, music can help to provide order in the environment, thereby increasing the likelihood that people will be able to focus and feel a greater sense of control over themselves and their surroundings.

The following ideas can be helpful to staff and family caregivers wishing to incorporate music into their existing program of care.

Singing

Singing can provide a wonderful means of interaction between caregivers and persons with dementia. This is a time when caregivers must put aside insecurities, such as worrying about having a pleasant voice or remembering the words or melody to a chosen song. In addition, they must let go of the expectation that the person with dementia must 'get it right'. These are not the most important elements of the interaction. Rather, the goal is to provide a time together to explore old songs and the feelings and memories they evoke.

Singing can be successful as an individual or group activity. Depending on the abilities of the people with whom you are working, you may be able to ask what songs they remember from the 'old days'. This can lead to the suggestions of a number of song titles, some you may know and others you may not. In the event that a song is suggested that is unfamiliar to you, it may be possible to ask the individual if she/he will share what she/he remembers of the song. You may hear the entire song or simply part of it, perhaps the chorus. Either way, encourage the individual to repeat what she/he has shared several times. During each repetition, try yourself to join in, even if you are only able to learn bits and pieces of the song. Your participation will help to encourage the person with dementia to keep going, and over several repetitions you may notice that the positive responses of the person will increase.

Repetition is very important. Too often, caregivers ask for or present a song and then only allow the opportunity for participants to sing through it one time. Given the presence of cognitive impairment, going through a song once usually isn't enough time for an individual to identify what is being presented and then to formulate and expand his or her responses to it. A suggestion is to repeat your songs between three and four times to allow for maximum participation.

Times that caregivers might wish to sing with participants can include times of loneliness or restlessness with individuals and during times of 'waiting' with groups (such as before mealtime). Some caregivers have also found singing with individuals to be successful during potentially stressful times, such as bathing and dressing. The addition of simple music to these situations can serve to provide something familiar and comforting that can ease levels of confusion and perceived threat. Most important here is to keep the choices simple and relatively quiet so as not to actually increase the confusion of the task you are trying to complete.

Singing for persons who are severely impaired and perhaps no longer responsive, can also be very rewarding for caregivers. Based on what you know of the individual, choose one or two appropriate songs and simply sing them quietly for him or her. In general, you will be most successful providing this stimulation quietly, without the expectation of a response from the participant. Songs in a waltz meter can be very appropriate here, as they are generally easy to match to the breath of the individual, and also tend to indicate a rocking or comforting atmosphere that is easy for people with advanced impairments to respond positively to. Some changes you may see are deeper breathing, relaxed body posture, changes in eye contact (opening or closing eyes) and possible vocalizations or verbalizations. Don't be discouraged if these signs aren't easily visible, however, as again, your goal here shouldn't be to get a response. Instead your goal should be to provide a unique 'gift' of yourself that may lead to some interaction with the participant.

Rhythm

Many caregivers often wish to use rhythm or percussion instruments as part of their activity programs. The addition of these

instruments to the setting can be quite successful and a lot of fun for both caregivers and participants.

When introducing rhythm instruments, it is best if possible to keep the group small, including no more than eight to ten participants at a time. Otherwise, the noise generated by the group may become overwhelming and the activity no longer successful.

Try introducing the instruments one at a time, explaining that your idea is to share something a little different with the group, and then offering people the chance to try out the sounds of the instruments individually. This presentation offers an opportunity for people to explore the instruments as well as to notice and interact with others in the group, rather than just being given numerous unfamiliar instruments and expected to be happy 'making noise' with them.

When each of the instruments has been explored, and each participant has one, there are several ways to proceed. Probably the most simple is to offer an upbeat song that can be accompanied by the instruments. As the facilitator, come prepared with several songs that can be used. This is not the time to ask for requests, as you have already established what is 'expected' of the participants. Changing their focus to thinking of songs will interrupt the flow of the activity. In addition, you may receive requests for slow, melancholy songs that are not consistent with the addition of rhythm.

Another option is to establish a steady rhythmic pulse at a moderate tempo, then verbally and/or visually encouraging members of the group to join in playing their instruments. This improvisation takes place without the immediate addition of a familiar melody, though it is possible that participants will spontaneously begin singing or vocalizing familiar melodies as the playing continues.

Conclusion

Roseann E. Kasayka, Karen Hatfield
and Anthea Innes

This book has provided for its writers the opportunity to explore two major tenets of person-centered care. To call them to mind again, these are, the needs of persons with dementia (love, comfort, identity, occupation, inclusion and attachment) and the elements of positive person work (recognition, negotiation, collaboration, play, timalation, celebration, relaxation, validation, holding, facilitation, creation and giving). These concepts are then applied in the realm of each of the healing arts therapies. In each of the chapters, case studies and pertinent case material illustrate the theory presented. Each chapter gives practical applications of art, music or dance/movement therapy to the practice of person-centered care, that therapist and non-therapist alike might employ. Each of the authors indicates that setting a space for the therapy to occur, paying attention to the visual and aural atmosphere, is important. The time given to this process is considered part of the session. After creating that space, making a safe container, the therapy may proceed.

The chapters describing art and dance/movement therapies go through the elements of person-centered care and describe the therapeutic process in the language of person-centered care. Looking at the case examples presented in these chapters one can easily recognize the previously stated hypothesis, namely, that person-centered care and these therapies are natural partners.

The discussion of the concept of identity in the dance/movement chapter is of particular note. This section addresses issues of gender and sexuality and the possibility of working with these issues through attention to bodily movement. The existing literature presents few clinical discussions and even fewer clinical examples of informed and compassionate methods of dealing with these issues. This section describes a unique opportunity and method of working with gender and sexuality.

The music therapy chapter takes a different approach to the application of person-centered care to the therapy. It is presented in terms of music therapy processes, the application of which supports personhood. Person-centered music therapy, a phrase coined by the authors of this chapter, is apt. Each of the examples given in the chapter describes how the basic needs of the individual as outlined by Kitwood (love, comfort, inclusion, attachment, identity and occupation) can be addressed by participation in music therapy sessions.

The chart that follows is a reprise and a summary of the interplay of positive person work as it is experienced through the application of art, dance/movement and music therapy techniques. It is meant to bring awareness and intelligence as well as the framework for observable behavior into the practice of positive person work. When you apply these techniques with awareness, positive person work is occurring.

Positive Person Work

Positive Person Work Elements	Experience of Participant	Art Therapy Techniques	Dance Therapy Techniques	Music Therapy Techniques
Recognition	Acknowledgement of unique presence and personal space Feeling of pleasure and being welcomed	Check in with color that reflects emotion Introduce art directive for the session with large visual cue	Eye contact Mirroring Attunement Touch as allowed Acknowledge each body part during warm-up	Verbal and/or musical welcome Acknowledgement of differences in playing style, participation
Negotiation	Sense of control over self and environment Relief from fear and/or inability to understand request	Offer choice of art materials Reflect rhythm/color of individual line qualities	Verbal/nonverbal invitation Assume body posture of participant to sense what is felt Offer out-stretched hand to lead the way	Provision of choice to participate as comfortable Reflection (by therapist) of musical actions initiated by participant

Collaboration	Feelings of partnership and no longer being alone	Encourage group drawing/painting on a single large paper or canvas	Invitation through open body posture, indicating 'you are welcome, and you won't be alone' Offer transitional objects such as ball, hat or cloth to hold	Improvisation – matching musical 'discussion', expansion of repertoire Choosing session content – songs, instruments, etc.
Play	Imagination encouraged	Use of any safe art media Encourage scribble drawings, abstract lines, shapes, blended colors Utilize questions such as 'What do you see?' or 'What does the image remind you of?'	Introduce movements of shaking, bouncing, swaying, stretching, reaching, kicking, etc. with rhythms evoking 'game playing' and story telling Introduce restful movements such as sitting, hiding, floating and rocking with words like 'let's imagine', 'what would it be like?' or 'how could we move when we were kids?'	Improvisation – musical discussion, exploration, 'how loud/soft can you play?', etc. Imagery

Timalation	Enhanced awareness of physical and psychic self	Use of clay 'How does it feel in our hands?', 'How does it emotionally move us?' Hand prints in the clay-reminiscence, comparison of hands, memories, etc.	Acknowledge smells and bodily functions – sweating, passing gas, being out of breath, feeling tingly, full, tired, pain, pleasure – with humor and reverence Model appropriate touching of peers', therapists' and own bodies Acknowledge and explore bodily sensations-'What feels good?', 'What is painful?' (either physically or psychically)	Live music presented to match breath of participant Appropriate presentation of novel musical elements
Relaxation	Decreased tension Feelings of safety	Drawing outside or to music Looking at colored cards & sharing reflections/feelings with group Watching others participate in the art process	Model and reflect relaxation by breathing, slowing down, yawning, stretching, sitting Suggest removal of shoes, loosening of tight clothing Offer touch (hand or shoulder massage)	Receptive techniques – listening, entrainment Stable musical environment to support relaxation process

Validation	Feelings of acceptance of current physical and/or psychic status	Feelings box – emotions written on 6-sided box; reflections on each by group; validation by therapist that all expressions are acceptable	Acknowledge unique movements, postures and expressions of each person Invite individuals with and without partners to center of circle Encourage support of all through touch, intention and verbalization Acknowledge those on the 'outside' of the circle as watching and holding the space Mirror movement and reinforce each persons presence and value as a group member	Improvisation – matching physical qualities of participant as well as musical, such as volume, timbre, texture Repetition of songs chosen by participant Acknowledgement of similarities between participant experiences
Holding	Feelings of safety, comfort and support	Acknowledge 'no right/no wrong' Offer structure of mandala (circle on paper/canvas) or object such as a flower pot	Invite each to take turn in center Encourage peers to hold hands in a circle Invite the intention of therapist and peers to hold person in the center of the circle	Provision of stable musical container – pulse, tempo, texture (all must be simple and constant to facilitate positive feelings)

Giving	Feelings of self-worth and contribution to community	Framing/matting artwork, then hanging it up Presenting resident/community artwork Creating cards for family/friends Exchanging artwork, spontaneous giving of artwork	Explore polarities of movement such as shrinking/growing, opening/closing, gathering/scattering, advancing/retreating Swaying back and forth Model and reflect movement away from and toward the heart, indicative of sharing and as an expression of holding on to/letting go of something or someone	Verbal acknowledgement of what each has to offer the group Musical processes involving sharing of instruments, space, etc. (drumming, improvisation, 'games')
Facilitation	Feelings of growth and/or expansion	Exploring new art materials Offer assistance (verbal visual and/or physical) to begin art process Discussing and/or dialoguing with images ('what might the tree be feeling, saying?') Assume body posture of image—leaning, bending, erect, open, etc.) Explore metaphor	Invite participants to focus on what will move or what wants to move Offer help to move a body part and provide space to explore that movement Offer transitional objects and reassurance that there is no wrong or right way, only your way Explore reminiscence of 'what we used to do'	Improvisation – exploration of unfamiliar media Lyric analysis for exploration and possible resolution of issues – provided at a level consistent with neurological strengths and deficits

Creation	Feelings of involvement and contribution to process Freedom of emotional and/or creative expression Positive changes in mood resulting from the therapeutic process	Group art making – focus on product as well as process	Encourage creation of something from nothing through movement (i.e. the making of a group space, dance, ritual, story or memory) Encourage release of imagination through movement, sound, rhythm Encourage and model symbolic blessing using movement and touch	Group improvisation Singing Assurance that some will participate actively while others receive/appreciate what is created
Celebration	Feelings of joy and connection with others	Encourage sharing and exploration of artwork created by group members Encourage awareness of accomplishments of group	Encourage and model physical and/or emotional connection with group members Encourage awareness of accomplishments of group	Encourage recognition of 'in the moment' joys and causes for celebration – being alive, being with others, awareness of beauty, etc. Encourage awareness of accomplishments of group

In the introduction to this book, it was stated that the healing arts therapies are those that take their form from the fine arts of music, dance and art. Practitioners of these therapies know that to be good therapists, they must be also practicing artists in the art form they use in therapy. The discipline one gains through practicing one's art gives validity to the therapy. This same type of discipline is needed when practicing the art of person-centered care. As we practice the fine art of living we gain the skills of awareness, sensitivity, compassion and respect needed to achieve facility in person-centered care. As we move from merely meeting needs to the practice of positive person work, the skill of fine and full living is refined.

The Contributors

Karen Hatfield is the Director of Healing Arts Therapies at University Hospitals Health System–Heather Hill Hospital & Health Partnership in Chardon, Ohio, USA. A Board Certified Music Therapist, she received her bachelor's degree in music therapy from Baldwin-Wallace College. She is currently pursuing a master's degree in music therapy from Temple University. She completed her training in person-centered care and Dementia Care Mapping with Professor Tom Kitwood of the Bradford Dementia Group.

Anthea Innes has recently begun work as a Research Fellow at the centre for Social Research on Dementia, University of Stirling. Prior to this she was a lecturer with Bradford Demtia Group and she continues to be involved in ethnicity and dementia research with BDG.

Roseann E. Kasayka is the Vice-President for Dementia Services and Healing Arts Therapies at Heather Hill. A Board Certified Music Therapist, she holds a doctoral in music therapy from New York University and is a Fellow of the Institute for Music and Imagery. She has done medical music therapy work as well as the work she now does with persons with Alzheimer's disease. Roseann completed her training in person-centered care and Dementia Care Mapping with Professor Tom Kitwood.

Natalie McClune, is a Board Certified Music Therapist at Heather Hill. She earned her Bachelor of Music degree in Music Therapy from Baldwin-Wallace College in Berea, Ohio. She currently serves people in areas of dementia care, long-term care and rehabilitation. Natalie has also completed her training in person-centered care and Dementia Care Mapping with Professor Tom Kitwood.

Holly Queen-Daugherty is the Art Therapist at Heather Hill Hospital and Health Partnership. She earned her Master's degree in Art Therapy from Ursuline College in Pepper Pike, OH, USA. She completed her fieldwork in the areas of pain management; terminally ill/indigent; emotionally/behaviorally handicapped adolescents/children; and Alzheimer's disease/dementia with the elderly. Currently, she is working in areas of Alzheimer's/dementia care, as well as long-term care and physical rehabilitation.

Liat R. Shustik is a Dance/Movement Therapist at Heather Hill and Health Partnership. She earned her Master's degree in Dance/ Movement Therapy with a minor in Counseling Psychology from Antioch New England Graduate School in Keene, NH, USA. Currently she is pursuing her combined passions for dance, healing and person-centered care in areas of Alzheimer's/dementia care, as well as long-term care and physical rehabilitation.

Tria Thompson is Chaplain for Dementia Services at Heather Hill. She holds an MA in Religious Education from Loyola University and an MA in Dance/Movement Psychotherapy from Columbia College. She employs the art forms of dance, ritual, storytelling and drama in therapy, ministry, liturgy and performance. As a dance/movement therapist, she explores innovative collaborative approaches to palliative care for persons with dementia.

References

American Dance Therapy Association (1999) *American dance therapy association population specific information* [brochure]. Susan Loman and Suzi Torton: Co-Editors.

American Music Therapy Association (1999) Website, www.musictherapy.org.

Association for Dance Movement Therapy UK (2000) Website: www.dmtuk.demon.co.uk

Bright, R. (1997) *Wholeness in Later Life.* London: Jessica Kingsley Publishers Ltd.

Bruscia, K. (1989) *Defining Music Therapy.* Spring City, PA: Spring House Books.

Brotons, M and Pickett-Cooper, P.K. (1996) 'The effects of music therapy on agitation behaviours of Alzheimer's disease patients.' *Journal of Music Therapy,* XXXIII (1), 2–18.

Chavin, M. (1991) *The Lost Chord: Reaching the Person with Dementia through the Power of Music.* Mr. Airy, MD: ElderSong Publications Inc.

Chodorow, J. (1978) *The reproduction of mothering, psychoanalysis and the sociology of gender.* Berkeley California: University of California Press.

Clair, A. A. (1996) *Therapeutic Uses of Music With Older Adults.* Baltimore: Health Professions Press, Inc.

Clair, A. and Bernstein, B. (1990a) 'A preliminary study of music therapy programming for severely regressed persons with Alzheimer's-type dementia.' *Journal of Applied Gerontology,* 9(3), 299–311.

Clair, A. and Bernstein, B. (1990b) 'A comparison of singing, vibrotactile and nonvibrotactile instrumental playing responses in severely regressed persons with dementia of the Alzheimer's type.' *Journal of Music Therapy,* 27(3), 119–125.

Cox, C. *MARI Course in Mandala Assessment.* April 19, 1999.

Cronin, S. and Werblowsky, J. (1979) 'Early signs of organicity in art work'. *Art Psychotherapy*, 6, 103–108.

Espenak, L. (1981) *Dance therapy theory and application.* Illinois: Charles C. Thomas.

Fitzgerald-Cloutier, M. L. (1993) 'The use of music therapy to decrease wandering: An alternative to restraints.' *Music Therapy Perspectives*, 11(1), 32–36.

Foth (1999) What is Art Therapy? *Buckeye Art Therapy Association* [brochure]. Cleveland, OH: Buckeye Art Therapy Association.

Graham, M. (1975) Martha Graham Lecture/Demonstration and Discussion at the Auditorium Theatre. Chicago, Ill.

Groene, R.W. (1993) 'Effectiveness of music therapy 1:1 intervention with individuals having senile dementia of the Alzheimer's type.' *Journal of Music Therapy*, XXX(3), 138–157.

Grossman, W. (1998) *To be healed by the earth.* Cleveland: Quality Books inc.

Hatfield, K. and Kasayka, R. E. (1996) 'The influence of individualized music therapy programs on depressed mood in Alzheimer's disease: A pilot study.' Heather Hill Hospital, Health and Care Center website, www.heatherhill.org.

Hatfield, K. and Kasayka, R. E. (1997) 'The effects of drumming using a table drum vs. hand held drums on persons with Alzheimer's disease.' Unpublished research, Heather Hill Hospital, Health and Care Center, Chardon, OH.

Innes, A. (2000) 'Expressing her grief in the only way she knew.' In Benson, S. (ed) *Person Centered Care: Creative approaches to individualised care for people with dementia.* London: Hawker Publications.

Johnson, C., Lahey, P.P. and Shore, A. (1992) 'An exploration of creative arts therapeutic group work on an Alzheimer's unit. The *Arts in Psychotherapy 19*, 169–277.

Jung, C. (ed) (1964) *Man and his symbols.* New York: Dell Publishing.

Kahn, K. (1983) 'The need for caring: Expressive therapy intervention for the Alzheimer's resident.' Unpublished paper, Cleveland, OH.

Kasayka, R. E., and Hatfield, K. (1995) 'The effects of sedative vs. palliative music on the relaxation of persons with late-stage dementia of the Alzheimer's type.' Unpublished research, Heather Hill Hospital, Health and Care Center website, www.heatherhill.org.

Kitwood, T. (1997) *Dementia Reconsidered: The Person Comes First.* Philadelphia: Open University Press.

Levy, F. (1992) *Dance movement therapy: A healing art.* Reston, Virginia: American Alliance for Health, Physical Education, Recreation and Dance.

Lewis, P. (1994) *The Clinical Interpretation of the Kestenberg Movement Profile.* Manuscript in Preperation, Antioch New England Graduate School.

Lipe, A. (1991) 'Using music therapy to enhance the quality of life in a client with Alzheimer's dementia: A case study.' *Music Therapy Perspectives* (9), 102–105.

Lipe, A. (1995) 'The use of music performance tasks in the assessment of cognitive functioning among older adults with dementia.' *Journal of Music Therapy,* XXXII(3), 137–151.

May, R. (1976) *My Quest for Beauty.* San Francisco: Saybrook.

Mills, M. (2000) 'The gift of her friendship'. In Benson, S. (ed) *Person Centered Care: Creative approaches to individualised care for people with dementia.* London: Hawker Publications.

Moon, B. (1995) *Existential Art Therapy: The Canvas Mirror.* Springfield, IL: Charles C. Thomas.

Packer, T. (2000) 'Barriers to person-centered care.' *Journal of Dementia Care* 8(6).

Petrie, T. (2000) 'Back into the swing of her sociable life'. In Benson, S. (ed) *Person Centered Care: Creative approaches to individualised care for people with dementia.* London: Hawker Publications.

Pollack, N. J and Namazi, K. H. (1992) 'The effect of music participation on the social behavior of Alzheimer's disease patients.' *Journal of Music Therapy,* XXIX(1), 54–87.

Poole, J. (2000) 'Building a bridge from philosophy to practice.' *Journal of Dementia Care* 8(5), 28–30.

Prickett, C. A. and Moore, R. S. (1991) 'The Use of Music to Aid Memory of Alzheimer's Patients.' *Journal of Music Therapy,* 28(2), 101–110.

Sandel, S.L. (1979) 'Sexual issues in movement therapy with geriatric patients.' *American Journal of Dance Therapy* 3, 4–14.

Sandel, S. L. (1992) Hearing testimony to the US Special Committee on Aging, 'Dance Movement Therapy and the Elderly, 18 June.

Sandel, S. and Johnson, D. R. (1987) *Waiting at the gate: Creativity and hope in the nursing home.* New York: Hawthorn Press.

Silber, F. and Hes, J. P. (1995) 'The use of songwriting for patients diagnosed with Alzheimer's disease.' *Music Therapy Perspectives,* 13(1), 31–34.

Stockley, S. (1989) 'Older lives, older dances: Dance movement therapy with older people.' In Payne, H. (ed.) *Dance movement therapy: Theory and practice.* New York: Routledge (p.64).

Tappen, R. (1997) *Interventions for Alzheimer's: A Caregiver's Complete Reference.* Baltimore: Health Profession Press.

Taylor, D. B. (1997) *Biomedical Foundations of Music as Therapy.* St. Louis: MMB Music, Inc.

Thompson, T. (1991) 'Full circle: Dance as healing ritual, opening and closing the process.' Unpublished master's thesis, Columbia College. Chicago, Illinois.

Tibbs, MA (2000) 'Amos: A self lost and found.' In Benson, S. (ed) *Person Centered Care: Creative approaches to individualised care for people with dementia.* London: Hawker Publications.

Whitehouse, M. (1979) 'C. G. Jung and dance therapy: Two major principles.' In Lewis Bernstein, P. (ed) *Eight theoretical approaches to dance movement therapy* (pp. 57–60). Iowa: Kendal/Hunt Publishing Company.

Winnicott, D. W. (1965) *The family and individual development.* London: Tavistock Publishers.

Subject index

health 72
Health Partnership 19, 49
Heather Hill Hospital, Health and
 Care Center, Ohio 7, 19, 49,
 102
'Help' (drawing, Mrs G) 35–6
holding 14–15, 58, 113, 118
holding music 70
'holding the space' 23, 67, 70, 72,
 90
hope vs. despair 76
hopes 42–3
horizontal plane 72–3
human spirit, regeneration of 9
humming 54

identity 12, 13, 21, 36–8, 45,
 52–6, 85, 88, 96, 107, 113,
 114
 'lost' 96
ill-being 92
illness 73
imagination 116
improvisation 64, 100, 116, 118,
 119
 group 92, 93
inclusion 12, 13, 21, 39–40, 45,
 52, 62–3, 69, 72, 85, 91,
 101, 107, 113, 114
independence 32
intentional touch 104
interaction 10, 77, 79, 91, 105,
 107
interpersonal interaction 10, 100
interpersonal relationships,
 meaningful 11
interventions in person-centered
 music therapy 92–101
 drumming 92–5

new experiences through
 person-centered music
 therapy 99–101
preserved music skills 95–9
interventions specific to persons
 with dementia at end of life
 101–6
intimacy 11
intuition 59
invitation 69–70
 verbal/nonverbal 115
isolation 39

joy 50, 80, 81, 120

kinesthetic attachments 56
kinesthetic awareness 51, 52, 55
kinesthetic empathy 53
kinesthetic inclusion 68
kinesphere, limited 68
Kulas Foundation 102

language deficits 11
late-stage dementia 102
legs 76
life history 107
lying on the ground 66
leaning on a tree 66
listening 73, 117
live music 106–7, 117
loneliness 39, 110
loss, sense of 35, 41, 50, 96, 98
love 12, 21, 32–4, 45, 46, 52, 58,
 65, 72, 107, 113, 114

masks 45, 65
massage 14
media and techniques in art
 therapy 30–2
melody 80, 109
memory
 loss, short-term 22, 52, 85

skills 99
merger 60
mirroring 53–4, 115, 118
moaning 82
mobility, decreased 71, 77
modelling 45, 60
monoprinting 31
mother and child 57
mothering 57–8
motivation 97
movement 49, 73, 77
 therapy *see* dance/movement
 therapy
moving 70
murals 11
musical instruments 100
musical skills 96, 97
musicians 95–6, 97
music therapy 7–8, 9, 10, 16, 27,
 113
 creating the space 88–90
 getting started: common
 approaches 85–8
 interventions in
 person-centered music
 therapy 92–101
 interventions specific to persons
 with dementia at end of life
 101–6
 positive person work
 techniques 115–20
 principles of person-centered
 care in 79–111
 recorded versus live music
 across continuum 106–7
 session type and therapeutic
 intervention 90–2
 suggestions for caregivers
 108–11

'My Hopes and Dreams' (painting,
 Mrs E) 42

narrative 13, 55
negative facial affect 104
negative self-talk 43
negative vocalizations 104
negotiation 13–14, 70, 113, 115
non-musical interaction 103
non-toxic media 31
nonverbal responses 91
nurses 85
nurturing 62

occupation 12, 13, 21, 42–3, 45,
 52, 63–5, 72, 85, 96, 107,
 113, 114
opening/greeting 70–1
organicity 23–4
orientation 10
over-exertion 77
oxygen through body, increased
 77

pain, soothing of 35, 60
palliative music 102
participation 83, 89, 101, 109
 in beauty 17
partners in personhood 51–2
passion 40
percussion instruments 100,
 110–11
performances 11, 97, 98
permission for therapeutic
 mirroring 53
perseveration 23, 27
personal contact 104
personal space 115
person-centered art therapy 19–48
 meeting basic needs 32–43
personhood 83, 107

space 119
short-term memory loss 22, 52,
 85
silence 91
simplicity 76
singing 80, 82, 91, 99, 102–3,
 109–10, 120
sitting 117
slowing down 117
small group settings 103
smells 116
social interaction 77, 92, 102
socialization 83
social psychology 51
social responses to music 80
social validation 55
songs 11, 103, 104, 109, 118
songwriting 84, 100
sorrow 61, 80
 soothing of 35, 60
soul
 expression of 49
 work 67
space
 creating 88–90
 preparation of 67–9
 sharing 119
spirit 72
spontaneity 44, 54
S-shaped curve 73
stability 100
stamping 31
'standing under' 51
stepping outside 66
storytelling 55
stress 71
stretch cloth 59
stretching 66, 117
'striking of a chord' 81

'Strokes of Green ' (drawing, Mr
 R) 26
'Subject of Support are My Wife
 and the Roots of the Tree'
 (drawing, Mr E) 25
subjective connection 55
support 118

table drum 92
techniques and media in art
 therapy 30–2
teenagers 27
Temenos 67
tenderness 35, 60
tension, decreased 116
texture 118
themes, exploration of 72–3
therapeutic alliance 51
therapeutic environment, creating
 29–30
'therapeutic fibs' 86
therapeutic intervention, session
 type and 90–2
therapeutic mirroring 53
therapeutic space, preparation of
 67
timalation 14, 71, 113, 117
timbre 118
tone 54
touch 49, 58, 71, 104, 115, 117,
 118
'touching of the heart' 81
traditional dancing 78
tranquility 81
transcendence 51, 59
transformation 76, 91
 of care 16
 of life 16
transitional object 37, 58, 60, 68,
 100, 116, 119

Author Index